Portrait

PHOTOGRAPHY

Portrait
PHOTOGRAPHY

Frank Herrmann

The Oxford Illustrated Press

THE OXFORD ILLUSTRATED PRESS

© Frank Herrmann, 1988

ISBN 0 946609 45 4

Published by:
The Oxford Illustrated Press Limited,
Haynes Publishing Group, Sparkford, Nr
Yeovil, Somerset BA22 7JJ, England.

Haynes Publications Inc., 861 Lawrence
Drive, Newbury Park, California 91320,
USA.

Printed in England by:
J.H. Haynes & Co Limited, Sparkford,
Nr Yeovil, Somerset.

British Library Cataloguing in Publication Data

Herrmann, Frank
 Portrait photography.
 1. Photography–Portraits
 I. Title
 778.9'2 TR575
 ISBN 0–946609–45–4

Library of Congress Catalog Card
Number 87-83275

Acknowledgements

I would like to thank the *Sunday Times*
for permission to use many of the
photographs in this book. My thanks
also to the people who sat for me in the
studio with so much patience as I
sought to demonstrate different lighting
effects. To Annette Lewin for her
drawings and to Brian Parry of Par-
liament Studios and Peter Marlow of
Magnum, who gave of their time to be
interviewed. Last but not least, to friends
and colleagues who have so kindly
allowed me to use their photographs.

All photographs by Frank Herrmann
unless otherwise stated

Diagrams by Annette Lewin.

Design by Roger Lightfoot.

Contents

Introduction

My first portrait was of the snowman we had sculpted, one cold and drawn-out winter, at the bottom of our garden. He was a considerable accomplishment with carrot nose, charcoal eyes and a tartan scarf. The wish to keep a record of such a fine specimen was only natural and he was a fitting subject for the twin-lens Ikoflex (a cheap version of the Rolleiflex) of which I had just become the proud owner.

The next step was to set up a darkroom and do my own developing and printing. What drew me to photography more than anything else was the magical quality of seeing a picture appear from nothing on a blank sheet of paper, as I rocked the developing tray back and forth, under a dim orange safelight. The combination of the scientific and technical side of my newly-discovered craft allied with all the artistic possibilities, proved irresistible.

There you have the two aspects of photography, technique and artistry, which it must be your aim to master. Sometimes they seem to pull in opposite directions but in reality it is their fusion which produces the truly worthwhile picture. Both are equally important—a beautifully visualised picture may be spoiled by poor technique just as a sharp, correctly-lit and exposed picture will be no more than a record without the artistic vision to give it meaning.

Technique often means attention to very simple things. We can all hold a camera steady at 1/125th second. Yet the professional will still use a tripod whenever possible, not only to eliminate the possibility of camera shake, but also to have greater control over the minutae of composition. It is only when the camera is static that you can pay really close attention to all the elements within the picture frame. Technique doesn't necessarily mean expensive gadgetry but it does mean attention to detail. If you do intend to work with the more simple fixed-lens camera, you can still take very good portraits but you need to be aware of its limitations and not attempt what it cannot achieve.

Ways of Seeing

Everyone has the ability to see creatively but it is something that needs to be trained and developed almost in the same way that an athlete trains and develops his body. You learn by studying the work of other photographers as well as through your own experimentation. Before you approach a subject you must be open to all the possibilities: change of lens, change of viewpoint, change of the depth of field.

Film is relatively inexpensive, certainly when using 35mm, so make many and varied exposures. The mistakes that you make can be learned from, especially if you keep a record of exposures, lens used, filters, lighting positions etc. Better to make a note at the time rather than depend on memory. Your successes will be satisfying but your mistakes will be there as something to learn from.

Approach to Technique

As with driving a car, it is only with continual use that the controls on the camera become second nature. You need to pass your camera test before the situation is reached where you can concentrate on your subject without continually worrying about the mechanics of taking the picture. In a way the automatic, auto-focus camera has made this a possibility from day one. But just as the use of the pocket calculator has eroded our basic ability to add and subtract, so the automatic camera makes all the technical decisions for the photographer, and the ability to make use of different techniques is impaired as is control over all the picture making elements.

While I remain suspicious of the trend towards automation in camera design, the advances in design and technique in all aspects of photographic equipment, are very welcome indeed. None more so than the electric-cell flash gun with its automatic control of light output (that is an improvement as welcome as the first flash bulbs must have been when they superseded flash powder.) There are other notable items such as the accuracy of the silicone-cell exposure meter and the increasing versatility of the tripod, an item which might be thought of as simple but in fact is a challenge to the best in design and function.

It seems only a matter of time before magnetic tape replaces light sensitive film as the image recording medium. No doubt this will increase the photographic possibilities even more than those which were created in the last century by the changeover from glass to celluloid. All the advances in technique, while exciting and sometimes challenging, don't alter the fact that great pictures have existed from the beginnings of photography, done by people with insight, sensitivity and creative ability. Improved techniques will help more of us to reach a certain level of competence but it is those other qualities which will enable us to take really worthwhile portraits.

Portraiture would be very boring if it were purely a matter of learning to light and pose a subject according to some well-thought-out formula. There are so many different ways of interpreting character and expressing emotion. I have set out in this book to cover problems and possibilities in portrait photography in a wide variety of situations: from studio to outdoors, posed to unawares, flash to tungsten, the purely flattering to the more interpretive.

Approach to Portraiture

The association of portraiture with newspapers is perhaps not immediately apparent. In my experience as a newspaper photographer for more than 20 years, a large percentage of one's work is actually spent portraying a very wide spectrum of people. The hundreds of profiles and interviews that appear daily are the most obvious example. Whether it's the front page story or a review in the arts, the sports' or women's pages, the gossip column or a city splash, they are all basically about people.

A camera is like a passport—you may enter people's homes, visit them at their places of work and travel with them on some expedition or undertaking they may be planning. Together with your subject, you both work at achieving the end result and when that partnership is functioning well, it can be very exhilarating. In newspaper work the ideal conditions rarely exist. One is continually grappling with problems, other than the photographic ones, to get the picture. As people become more famous, so the demands on their time increase and the less time they are willing to allow the photographer. It is very difficult to establish a rapport, to achieve an understanding and an insight into the character of your subject, under these conditions.

The public figure is very aware of the side of his personality that he wishes to be revealed. To some extent you know that you, the photographer, are being used. Politicians are the most adept at getting the photographer to take the picture that will project the 'right' image. It almost develops into a game of cat and mouse—politician kisses baby while photographer waits for the proverbial banana skin. Party conferences give the best opportunity for a more revealing portrait. Not the open-mouthed, chin-forward, finger-pointing cliché picture of the speaker but rather of the avid (or not so avid) listener. The front row of ministers who remain in a fixed spot for many hours at a time offer plenty of scope for the patient photographer.

What makes portraiture so absorbing is the wide range of individuals you encounter and this is particularly true for someone working in the newspaper industry. The diversity is a continual source of surprise, from a snail farmer in Somerset to an astronomer in Bedford studying the stars from the cabbage patch in his back garden. These people are always interesting to meet and a pleasure to photograph. They are absorbed in their hobby or endeavour and have no concern beyond communicating their enthusiasm.

People of great talent—musicians, writers and painters—whose dedication to their work is total, are the most rewarding subjects of all. The sculptor Giacometti, whom I photographed in the sixties arranging his exhibition at the Tate, was so absorbed in what he was doing that I had the feeling he was quite unaware of my presence. How astonishing to find the man, gnarled and spindly, resembling his own remarkable sculptures in so many ways. The juxtaposition of the artist and his work, the musician and his instrument, is always latent with possibilities, whilst presenting a challenge to avoid the obvious.

Most difficult to photograph and achieve anything of lasting value, are the captains of industry. They seem to wish to grace the pages of newspapers and annual reports not as individuals but as symbols of rectitude and efficiency. As you come through the door they are already busy tidying up the desk top which might reveal the slightest human fallibility. The desk top is the last thing I am interested in. I look for some sign of character such as bushy eyebrows or furrowed brow and try to concentrate on that. It is always a sense of real achievement when you come away from a business assignment with a worthwhile portrait.

Wars, disasters, political movements, world events, very often are of such vast dimensions that in order to move the reader from an abstract to a more emotional involvement we focus on a single person. We show the event by catching the fleeting emotions reflected in a face. The weary, haunted faces of US Marines in Korea by David Douglas Duncan were a memorable part of *Life* magazine's coverage of that war, as was the portrait by Martin Rougier of a Korean orphan struck dumb by all he had suffered. The picture story on that one child caused such a revulsion against the war that spontaneous donations were sent to relieve the plight of the innocent victims.

Bert Hardy and James Cameron were the team sent out by *Picture Post* to cover the war in Korea. One of the stories they sent back had the most compelling photographs of South Korean political prisoners, cowering and tied together in a long chain. The proprietor, Edward Hulton, refused to run either the story or the pictures on the grounds that it could lessen the public's support for the war. The picture editor, Tom Hopkinson, refused to take it out on the grounds that this was happening and knowledge of it should not be suppressed. In the event Tom Hopkinson resigned over the issue and many of the talented members of *Picture Post* drifted away over the following months. It eventually closed, partly a victim to the power of those portraits by Bert Hardy which were never shown at the time.

The starving child, so frequent an image of the twentieth century, is one that can never fail in its stark emotional appeal. It is the sort of picture that has

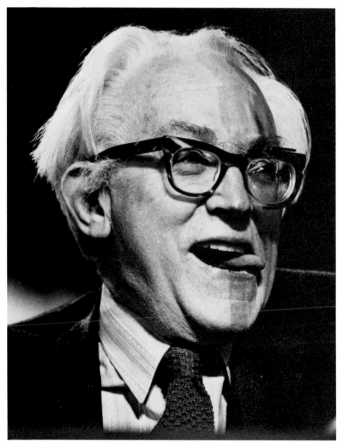

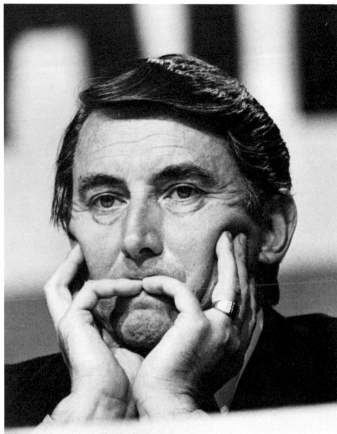

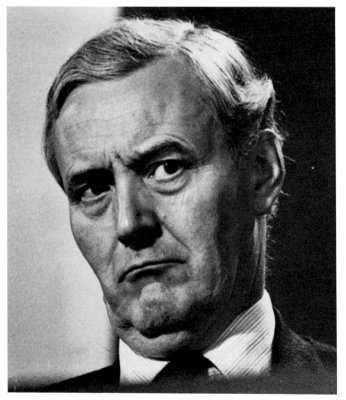

Party conferences are excellent
occasions for capturing a whole gamut
of expressions in our leading politicians.
They have to spend many hours, not just
listening to speeches but sitting under
the watchful scrutiny of stills and
television cameras.

Kodak Tri-X rated 800 ASA, Nikon 300mm,
1/250th sec @ f2.8

been referred to as social pornography and, while it has been successfully used by charities and the media to raise many millions of pounds for relief organisations, there is the ever-present danger that constant horrific images of mankind's suffering may finally cause a lessening of our response and end in voyeurism.

The single event that most dominated the sixties was the assassination of President Kennedy in 1963. Apart from some very amateur film footage, the public shooting of the President went totally unrecorded. I was sent to the US Embassy in London and looked into the faces of those who had come to pay their respects. The assignment itself was trivial in the sense that any result would be a poor second to a picture of the actual event, but nevertheless something of the tragedy came from the care and hurt shown in a young woman's face. This and the following two examples are intended to show how portraiture may be used as the means of relating the reader or viewer to an event.

The British Trans-Arctic Expedition took 18 months to cross from Barrow in Alaska to Spitzbergen and here it was the snow-encrusted face of the explorer Alan Gill that best portrayed the endurance and tenacity of man pitted against nature. But far more frequently used and challenging in a different way are the everyday pictures—the times when the picture is needed to fill the space. The challenge here is to avoid the cliché and come up with a fresh view of situations that have been portrayed many times before. The British obsession with their weather means that every Press photographer has at some time or other had to illustrate some aspects of its extremes. The example I have chosen was the over-80° Fahrenheit variety and the old lady enjoying her ice cream in the shade.

The possibilities for portraiture are all around us. The joy of taking pictures was surely the inspiration for most professional photographers in their choice of career. Once the professional has lost his amateur status his motivation has changed. Photography has become his sole means of earning a living and he may very easily lose the initial wide-eyed approach. The enthusiasm of the keen amateur is his greatest asset. The portraits you take need please no one but yourself and the subject matter is all around you. Whether it's children in the playground, market stall-holders in the city or the rugged

weather-worn face of fisherman or farmer, the possibilities are endless.

On the other hand, if your interest lies more in the carefully-posed and well-lit portrait, finding suitable people to sit for you may be something of a problem. Not many of us are like Julia Margaret Cameron, who apparently had the ability to persuade perfect strangers whose faces she wished to portray to come and sit for her. That was before the days of model fees and sexploitation, so perhaps it is understandable that people were less wary. Friends and neighbours are more likely to be helpful and probably a little flattered at your interest, as well as grateful for the prints you give them afterwards.

The portraiture that I have been describing is documentary in nature and only one aspect of a newspaper photographer's work. Equally absorbing is the interpretive architectural portrait which seeks to show the person in relation to his or her environment and through that interplay, illuminate the person's character and build the final image. The American photographer Arnold Newman is the great exponent of this type of portraiture. It is interpretive at the moment of shooting but nevertheless relies upon the research done beforehand for a successful outcome.

The face itself viewed almost as a landscape is endlessly interesting. You only have to look at the portraits of Yousuf Karsh, the acknowledged master of the well-lit portrait, to marvel at the textures and plasticity revealed through his control of lighting. There is also a lot of emphasis on the pose and expression but with a 10 x 8 camera and the necessarily long exposure, spontaneity must be lost. I always find myself more impressed by the technique than moved by the portrait. An artificiality has come between the viewer and the picture.

In both types of photographic portraiture—man and environment, man as sculpture—the photographer is pre-eminent, his presence strongly felt. With the portraits of Henri Cartier Bresson the photographer's presence is barely felt. Here is the master of the unposed portrait so adept at catching the synthesis of subject and surroundings. The decisive moment, a phrase derived from the English title of his first book of photographs, has caught the subject so naturally and at such a revealing moment that the viewer feels himself actually present at the scene. The photographer has absented himself and

thereby tried to minimise his influence on the presentation of reality. No tripod, no fixed position here, just an ephemeral figure constantly observing. The post-war Leica camera much loved by Bresson, was a shiny metal object and much too noticeable, so he covered the bright parts with black tape. That caught on amongst aspiring photographers, until finally the manufacturers produced the now prevalent black-coated cameras. However the manufacturers like their equipment to be as noticeable as possible and are now busy popularising bright coloured neck straps printed with the camera's brand name.

Another photographer with a dominant influence on photography, and particularly portrait photography, has been the American Irving Penn. His series of people in all walks of life, very often with some object of their trade or profession alongside them, are striking by their simplicity. The pose is always direct to camera, the background a uniform grey and the lighting frontal daylight. It's a good honest pose, 'I'm sitting here like this because I've been asked to by the photographer and I've nothing to hide. Take me as I am'.

History of Photography

There seems to be a strong affinity in these Irving Penn portraits with some of the early Victorian photographers. Simple full length poses and bright daylight studios were the order of the day, when just getting an image on the plate required so much skill and patience.

The invention of photography by Daguerre and Niecephore Niepce was announced to an astonished world at the French Academy of Sciences on January 7th, 1839. Niepce, whose pioneering work led to the discovery, had died in 1833 four years after signing the articles of partnership, to develop the invention, with Daguerre. The glory now all went to Daguerre and those early photographic copper plates became known as Daguerrotypes. In England, Henry Fox Talbot had been working along similar lines and now hastened to publicise his discoveries by rushing samples of his work to The Royal Institution on January 25th, 1839.

The Daguerrotype, a negative image on a highly polished metal plate, was the generally adopted process. Fox Talbot had invented the negative-positive process. His negatives were made from paper and this greatly impaired the quality of the final print.

Portraiture, though greatly sought after, was almost impossible at first because of the long exposure times. Indeed after the initial excitement, interest in the new medium lay dormant until improvements made the taking of portraits a realistic possibility. A contemporary account of a portrait session describes the ordeal: 'I sat for eight minutes with the strong sunlight shining on my face and tears trickling down my cheeks while the operator promenaded the room with watch in hand, calling out the time every five seconds, till the fountains of my eyes were dry.'

In spite of the difficult conditions two Scotsmen, the painter David Octavius Hill and the chemist Robert Adamson, produced a notable series of portraits in the 1840s using Fox Talbot's calotype process. In general however, the Daguerrotype, with its superior qualities of tone and fine detail, was the preferred process until 1851, when the discovery of the collodion wet process enabled glass negatives to be used instead of paper and the Daguerrotype became obsolete. Portraiture was in great de-

mand but people found the uncompromising realism of the camera a little daunting and photographers soon found ways to flatter their client's sense of importance and self esteem by introducing props. The book was a favourite symbol of wisdom and the Grecian pillar of cultural values. However, Nadar in France would have none of this. His portraits are bold, straightforward and invincibly honest and he became justly famous for them.

Julia Margaret Cameron was in her fifties when she took up photography as a hobby at her home in the Isle of Wight. She knew many of the famous men of letters and her aim was to 'record the greatness of the inner spirit as well as the features of the outer man'. There is a wonderful aliveness to her portraits and she often used slight movement or a shift in focus when it suited her purpose. No one was safe from her demands—if a face interested her, even a stranger, then they would inevitably end up in her studio.

The modern era of photography was really ushered in in 1925 with the

invention of the Leica 35-mm camera. The German photographer Erich Salomon was soon to show off its remarkable capabilities with his coverage of behind the scenes meetings of politicians and statesmen, mostly taken in very poor light. Unheard of for the day, he needed no flash and his discreet presence was hardly noticed by the participants. Obviously advancing techniques and improved equipment, do enable the photographer to capture images previously unobtainable. But the essence of good portraiture remains in the visual and psychological perception of the photographer. The better your mastery of the technical, the more you can concentrate on the subject matter. The more you know of the technical possibilities, the easier it will be to put your ideas into practice. Trial and error are the best tutors but also the ability to analyse and learn from your mistakes. The aim of this book is to motivate you to go out and make those trials and to refer to them when seeking to correct the mistakes.

Neil Kinnock in his home town of Tredegar. Kodachrome 64, Nikon 85mm, 1/60th sec @ f8

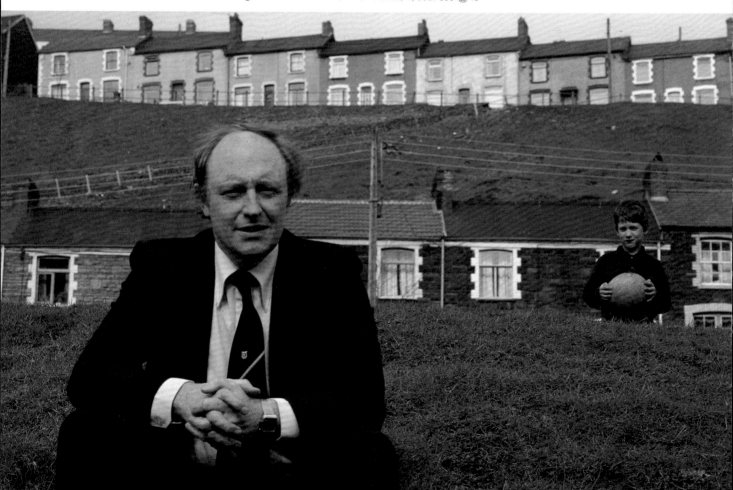

Amateur astronomer settles down amongst the cabbages in his back garden for a night of star gazing. A mixture of ambient twilight and flash fired from an off-camera position.

Kodak Tri-X, Nikon 50mm, ¹/₂ sec @ f8

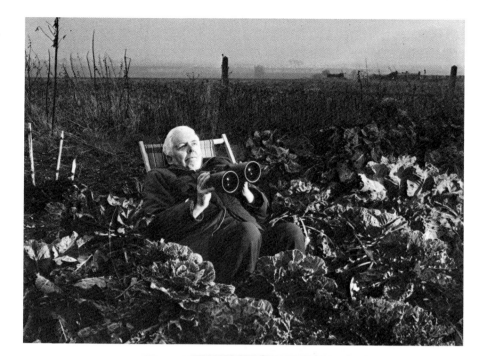

West country snail farmer. It's surprising how quickly a snail moves when you want it to stay quite still! The snails are no more than 9 inches away from the lens. I needed to stop the lens right down to get the necessary depth of focus but was wary of getting a blurred snail at anything slower than 1/60 sec.

Kodak Tri-X, Nikon 50mm Macro, 1/60th sec @ f22

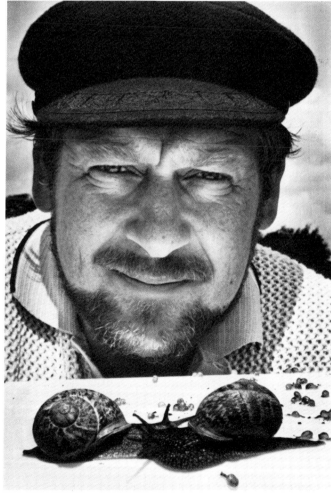

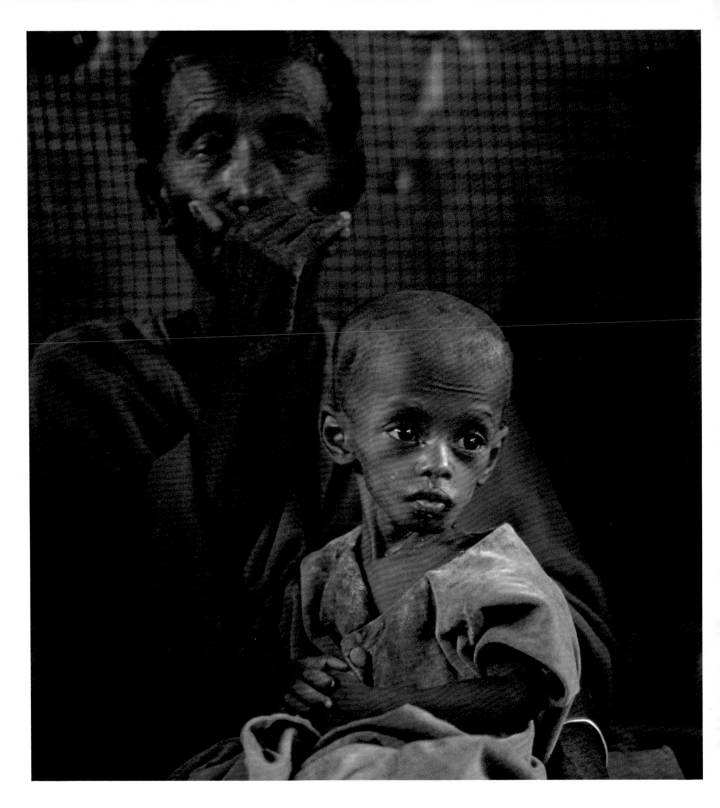

**Starving Ethiopian child photographed
at Alomata refugee camp.**

Kodachrome 64, Nikon 50mm, 1/15th sec
@ f2

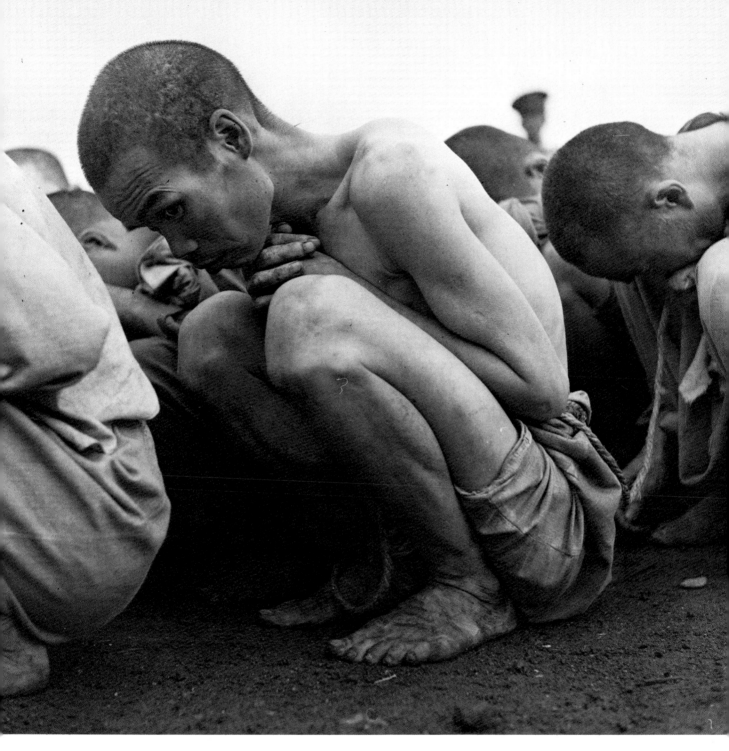

South Korean political prisoners, cowering and dressed in rags. This was the story that was never shown at the time. Taken by Bert Hardy for *Picture Post* when he was sent to cover the Korean war with writer James Cameron.

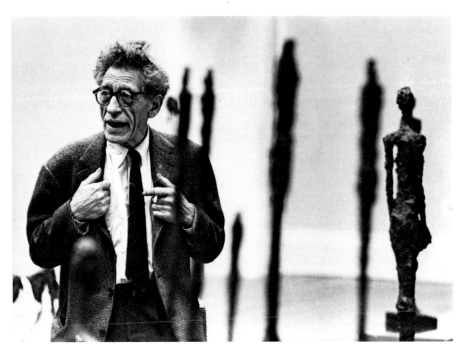

Alberto Giacometti oversees the setting up of his exhibition at the Tate Gallery in 1965.

Kodak Tri-X, Nikon 105mm, 1/125th sec @ f4

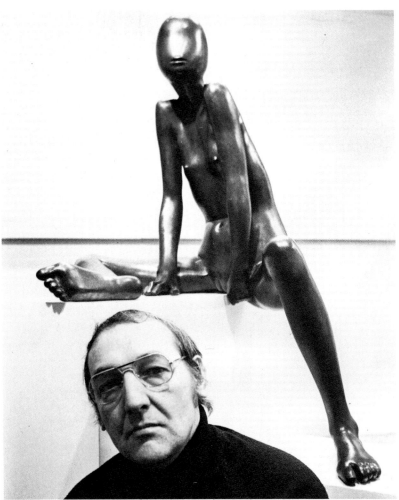

Ralph Brown at the Royal Academy with his sculpture of a young girl.

Kodak Tri-X, Nikon 35mm, 1/15th sec @ f11

14

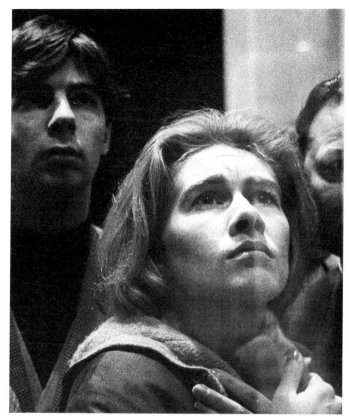

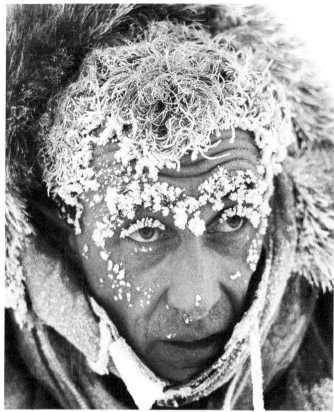

Above left: **At the United States Embassy in 1963 after the assassination of President Kennedy, hundreds of people queued to pay their respects and sign the book of condolence. The grief and anguish shown in this young woman's face reflected the concern felt throughout the western world.**

Kodak Tri-X, Leica 35mm, Tungsten lighting, 1/30th sec @ f2

Above right: **Allan Gill, one of the four members of the British Transarctic Expedition. The most graphic way of showing the harshness of the conditions was in a close up of the explorer's face. During December and January in the arctic circle, the light is never brighter than a dim twilight around midday.**

Kodak Tri-X rated at 800 ASA, Nikon 50mm, 1/60th sec @ f1.4

Left: **The good weather picture. A hardy perennial for the press, usually resolved by photographing a bikini-clad nymphet in some watery situation. It becomes a challenge to obtain a different image. I found this old lady in my local park, enjoying her ice cream in the shade.**

Kodak Tri-X, Nikon 300mm, 1/1000th sec @ f5.6

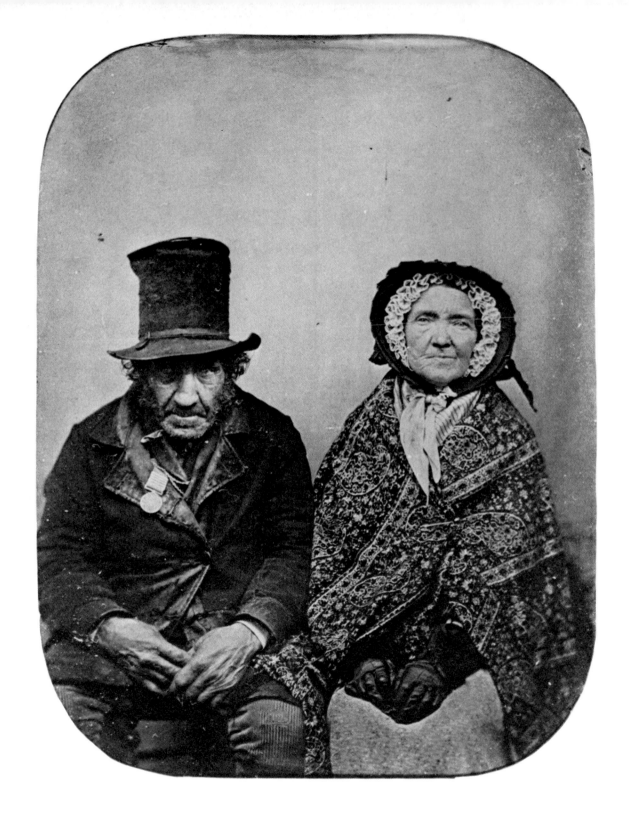

This striking dual portrait (photographer unknown) taken c. 1860, is titled 'An Elderly Veteran and His Wife', and conveys so much about the ordeal of having your picture taken and the different character of the two individuals – he, cowering and at the same time proud to show off his Waterloo campaign medal, she, determined and undoubtedly the driving force in the marriage as well as the photographic session.

16

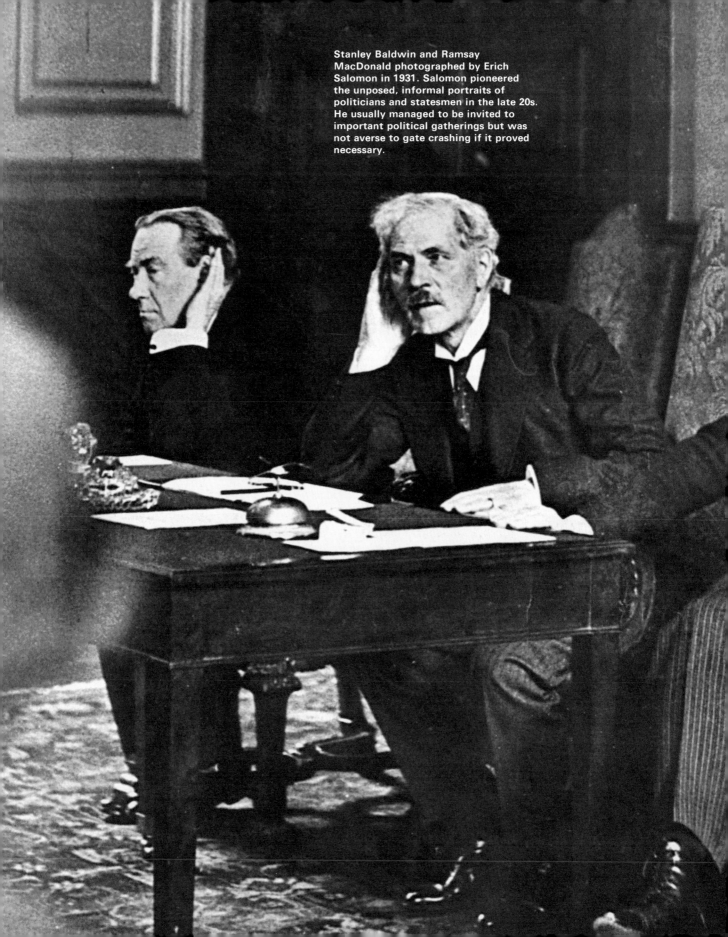

Stanley Baldwin and Ramsay MacDonald photographed by Erich Salomon in 1931. Salomon pioneered the unposed, informal portraits of politicians and statesmen in the late 20s. He usually managed to be invited to important political gatherings but was not averse to gate crashing if it proved necessary.

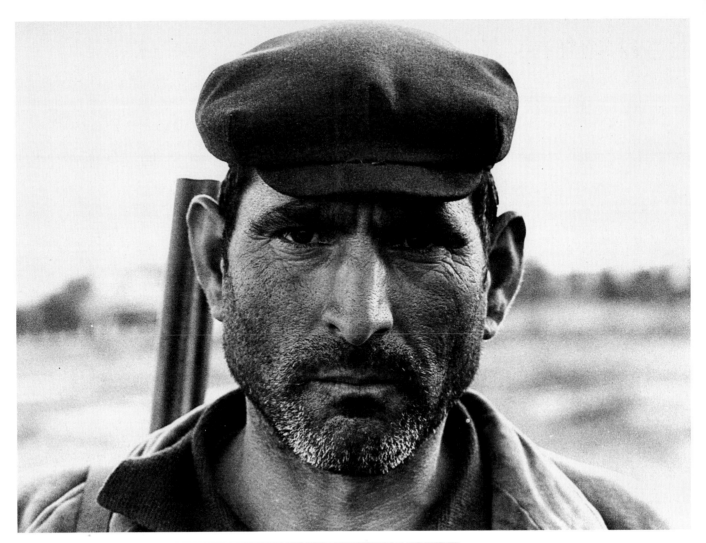

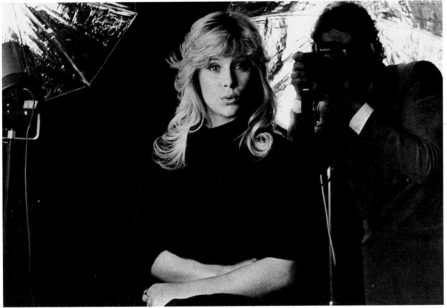

Left: A wide range of people are photographed daily in the Press. On the left Duncan Baxter has photographed Samantha Fox, making a feature of the studio lights—symbol of the top model's working life.
Above: The chilling face of a Sardinian bandit photographed by Peter Dunne when he was working on the Schild kidnapping story.

Equipment for Portraiture

Every budding photographer will have been given a very simple camera to start with and experienced the frustration which such an instrument imposes. You may know the sort of picture you wish to achieve but the limitations of the camera at your disposal make this impossible. The tendency over the years has been for manufacturers to concentrate on taking the decision making away from the photographer and letting the camera work it out for you. In other words the automatic camera. Up to a point this has meant that the vast legions of happy snappers are producing far more acceptable results. The customer is being satisfied. But where you wish to go a little deeper with your photography, the degree of control you maintain over the operation of the camera is of vital importance. The limitations on creative work with the simple camera are threefold:

1. *The separate viewfinder:* It is only when the taking lens is the same as the viewing lens as in the Single Lens Reflex (SLR) camera that you can be 100 per cent sure that the picture you see in your viewfinder is identical to the picture exposed on your negative. The problem is parallax or the non-alignment of viewfinder and taking lens. Where you may want to take a close up, the parallax effect is especially apparent.

2. *The fixed lens:* A simple camera will only allow you to shoot with the one standard lens thus drastically limiting your ability to affect the final image. A standard lens has a focal length approximately equal to the diagonal of the film format. Thus the standard lens for a 35-mm camera is 50mm and for a 6 x 6-cm camera the standard lens is 80mm.

3. *Automated control:* A useful addition to manual control but if there is no way of overriding it then you will not be in complete control of the shutter and aperture setting which can significantly alter the effect of your picture.

The automatic controls increasingly available with modern cameras are worth examining for a moment. The through-the-lens (TTL) metering systems are becoming ever more sophisticated. The centre weighted system bases its exposure calculations towards the central area of the photograph. Even so, a very dark or conversely, a very light background will still cause the meter to change its calculation. In fact the light on the face remains the same and therefore the exposure should remain the same. Here you can use the TTL system almost as a hand-held meter by taking a close-up reading of the subject or applying a long focal length lens to pick out exactly the area you wish.

Exposure Display

The exposure display in the camera viewfinder is a factor worth thinking about when you purchase a camera. The matching needle is an excellent system. If you wish to deviate from the indicated correct exposure, you can read off exactly the amount of correction in the viewfinder. The only disadvantage with this system is that it does not light up. If you are photographing from a darkened area into a light area, as you would be when photographing a performer in the theatre, the exposure display in your viewfinder will not be visible. This drawback is overcome by the LED or illuminated display of a plus or minus sign to indicate exposure. When the two signs appear together your exposure is correct. The disadvantage with this system is that the plus or minus sign does not indicate to what degree you are over or under exposing.

Having established that we require an SLR, changeable lens manual, plus if desired automatic metering control camera, we still have an enormous range of brands to choose from. The basic standard of such cameras is nowadays extremely high in lens performance and reliability. On performance alone the costlier and better-known brand may not in fact be of any advantage. The one overriding consideration in choosing the more expensive brand would be in the vast range of accessories that your chosen system, such as Nikon or Canon, would have available. Whatever area your photography may lead to, avoid choosing a system where expansion is limited. Another consideration could be the sort of use to which your equipment will be subjected. A Press photographer will expect to subject his cameras to some very vigorous treatment. They will probably be exposed to rain and snow (as yet there's no antidote to salt water so in those conditions even he will have to take precautions). The only reason I can see for buying the top of the range Nikon F3 for instance, would be its sturdy construction and very fast motor drive, essential for sports photography.

Medium-Format Camera

In discussing choice of camera so far I have been assuming that a beginner will start with a 35-mm camera and indeed for the vast majority of Press photographers there will never be any need to opt for a larger-format camera. With the quality of present day materials, there may seem little purpose in going for the larger-format 120 roll-film camera. However if you are serious about portraiture and intend to do a lot of studio work, the extra negative size will give your prints the edge. I have often been challenged to see if I can pick out a 35-mm from a 120 print and the results can be extremely difficult to differentiate, but consistent quality of detail and

19

tone will be much easier to achieve with a roll-film camera. The 120 roll-film camera comes in three different sizes: 6 x 4.5, 6 x 6 and 6 x 7. The 6 x 4.5 is not that much bigger in negative size than the 35mm. The 6 x 6 is restricting in its square format and I myself would favour the 6 x 7. The one proviso with a rectangular-format 120 camera is that you purchase one with a revolving back. Otherwise this camera is very awkward when used on its side in the portrait or vertical position. Apart from the greater negative quality obtainable with these larger format cameras, the larger viewing screen does help when composing your picture and the ability to use a polaroid back and check lighting and composition, can be a considerable advantage. The polaroid back, when it replaces the conventional film carrier, converts your camera to a polaroid with all the advantages of instant pictures.

Lens

The question now arises of which lenses to buy for your chosen camera. The standard lens would seem a good one to start with though in fact it is the one I use the least. If financially possible start with two lenses. The slightly shorter than normal 35-mm lens and slightly longer than normal 85-mm lens will enable you to take portraits with surrounding detail in them, as well as close-ups of head and shoulders. The reason that the close-up and the general view cannot be covered adequately by

the one lens, is to do with perspective. As soon as you come closer to the subject to go from full length to head and shoulders, you change the perspective. This changed perspective means that objects in the foreground, such as the nose, become bigger whilst objects in the background, such as the ears, become smaller. In the illustration I have taken this to its extreme and the face in the first has become so distorted due to the extreme perspective that it is no longer recognisable as the same face in fig 2. With this in mind you will understand that a lens about double the normal (that is 105mm for a 35-mm camera and 150 for a medium-format camera) is considered the ideal lens for a head and shoulders portrait. Where you are photographing a group of people you may now have the choice, according to which lens you use, of exaggerating the size of the figure in the foreground relative to the other figures or else taking a more distant viewpoint, selecting a longer focal length lens and thereby equalising the relative size of the faces in the group. It all depends on the effect you wish to create and having the choice of lens allows you to do this. The characteristic of a longer lens, which must be noted, is that the longer the lens the smaller the depth of focus. This can be an advantage where you wish to throw the background out of focus and a disadvantage where you wish to keep all the figures in focus. Another even greater determinant in the depth of focus is the size of the aperture. The

Distortion lies in distance between subject and camera not, as is sometimes supposed, in the focal length of the lens. In order to fill the frame for a head and shoulders portrait, you would need to be very close if using a wide-angle lens. This would result in the nose appearing large relative to the ears. The further you go from the subject, the less the distortion but in order to fill the frame you now need a longer focal length lens. With the 35-mm format, the 105-mm lens is considered ideal for the head and shoulders portrait.

1. **With 105mm lens**
2. **With 35mm lens**
3. **With 24mm lens**

By changing the focal length you can either lay emphasis on the background or cause it to disappear.

4. 50mm lens @ f16
5. 180mm lens @ f2.8

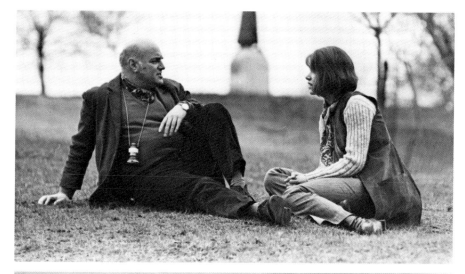

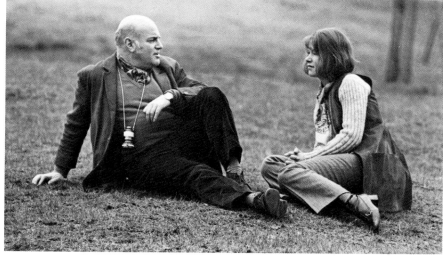

Right: **During a break in the filming of 'Sunday, Bloody Sunday', I had the opportunity to photograph director John Schlesinger and leading lady Glenda Jackson. I was able to eliminate a disturbing background by raising my viewpoint. A light aluminium step-ladder is kept in the boot of my car at all times, for occasions such as this.**

smaller the aperture, the greater the depth of focus.

Zoom Lens

There are many high quality zoom lenses on the market nowadays and this is a useful lens where you wish to lighten the amount of equipment that you carry with you. However they are slightly unwieldy to use and a stop or two slower than normal lenses. This means that the brightness of the image in your viewfinder is curtailed and you may have to use a slower speed than you would wish, in order to compensate for the loss of aperture. I would always prefer using an ordinary lens where practicable although it is worth mentioning that interesting effects can be created in portraiture and other fields by actually zooming the lens during exposure.

Teleconverter

The teleconverter is a useful extra, where another lens might be too expensive or too bulky to carry around. When placed between lens and camera it increases the focal length by x $1^1/2$, x 2 or x 3 according to which teleconverter is fitted. The drawback is some loss of lens performance and a reduction in the effective f-stop of the converted lens.

However with some of the more expensive teleconverters which are specifically matched to the focal length of a lens, loss of performance is minimal. Before leaving the subject of lenses, let me mention the autofocus lenses which are coming on the market in increasing numbers. So far they have not been able to compete with the quick reflexes of the sports photographer. It is in this field, where instant focus is so difficult and so essential, that the true worth of the auto-focus lens remains to be tested. One awaits developments with interest.

Tripod

Although lighting these days in the studio is far more likely to be flash than tungsten and therefore the question of camera shake is irrelevant, a tripod is still necessary and needs to be purchased with some deliberation. Having the camera in a fixed position leaves you free to make careful lighting adjustments, to pose and compose the picture. Other lighting situations such as daylight or a mixture of flash and daylight, require longer exposure times. Here a good sturdy tripod is essential along with a 30-cm cable release to eliminate the possibility of camera shake. A ball and socket head is excellent for quick and easy control of

camera movements and the reversible centre column enables you to use the tripod from floor level to its fullest extension of 7 or possibily even 8 feet. In situations where a tripod may be too cumbersome or awkward to use, the unipod is an excellent alternative way of steadying the camera. It is light to carry, takes up minimum space and is particularly useful when using a lens of long focal length. With longer focal length lenses the effects of camera shake are greatly magnified. They are also heavy and when shooting over a longer period, a unipod can be essential.

Lens Hood

Any light which is not within the lens' angle of view may still be entering the lens. Instead of forming the image, it is interfering with it. To be sure of optimum definition always use the appropriate lens hood. These are coated internally with a matt black paint which should be touched up when signs of wear appear.

Cable Release

For longer exposures, anything over 1/60th of a second, it is advisable to use a cable release when triggering the shutter. Even with a sturdy tripod, finger contact may cause camera shake.

The Quality of Daylight

The photographic novice often seems to think that a clear sky and bright sunlight at noon guarantees ideal light for portraiture. Nothing could be further from the truth. Probably the best way to cope with that situation, which would cause harsh shadows and narrow squinting eyes, is to turn the person around so that the sun is behind them and with reflectors bounce a more even, softer light back into the face. Lightened surroundings, such as walls and light paving stones, can often act as natural reflectors but just by giving your subject an open newspaper to hold, you will be surprised at the amount of light that is reflected into the face. Knowledge and understanding of the qualities of light are an integral part in the creation of a good photographic portrait. The photograph is made up of a sum of vital elements and not least among these is the lighting. Obviously daylight cannot be manipulated to the same degree as studio lighting but changing your position, choosing the time of day and use of reflected light, can all contribute to a portrait that is essentially natural and devoid of the artificiality that is often the hall mark of a carefully lit studio portrait. Many photographers in advertising and editorial work have tried in the studio to simulate the gentle, attractive effects of diffused daylight. It can be very difficult, as you look through current magazines, to be certain whether a portrait is really taken by daylight, as seems apparent, or artificial light to give the same effect.

The strong back-lit photograph described in the previous paragraph is necessarily quite dramatic, with its rim lighting. Often a better solution, depending on the effect and mood you wish to create, would be to head for an area of open shade. With a cloudless sky you may still find unsightly shadows under the eyes which require lightening by means of a reflector. On a day with large puffy white clouds, which scatter the sunlight and lighten the shadow areas, you will find the light far more flattering to your subject. Texture, plasticity and strong modelling of the features are all emphasised in this gentle sunlight. Now the height of the sun is important. The low early morning or evening sun will flatten the features but illuminate the eyes, giving a strong, bold, confrontational portrait. As the sun moves higher, the shadows shorten and the face can be turned at an angle to the sun giving greater modelling to the features and roundness and depth to the face. In England there are only the three summer months when the height of the sun can be a problem, causing unacceptable shadows in the eyes and cheeks. Not so in southern countries, especially those approaching the equator, where the sun will be directly overhead. In these circumstances it is better, if at all possible, to confine your outdoor portraits to the early morning or the late afternoon.

Everyone will have noticed how low, angled sunlight brings out the texture in things—a flaking wall or cobbled stones. In the same way skin textures, the character lines of experience, the wrinkles of old age, all these will be more apparent according to the quality and direction of light falling on them. Skin tones will be improved and blemishes diminished in a soft diffused light, the very light which is common in England with its preponderance of grey overcast days. It is equivalent to the north-facing studio light so loved by the Victorian photographers. In a studio, however, the direction of the light from its source, the window, is very definite. Outside, even when the sky is overcast, you still need to be aware of the direction of the light and place your subject facing the direction of the sun, were it visible. With a heavily overcast sky the light will become top heavy. The actinal values are too low to create strong reflective light and the eyes, being lit mainly from above, lack sparkle. The best solution here is a very slight amount of fill-in flash. Too much and you ruin the atmosphere. It has to be done with some care and I will go into this further in a later chapter.

Tonal Distribution

In talking about the quality of daylight I have ignored an element in portrait photography that should always be uppermost in your mind. This is the relative light value of the subject to its surroundings. A light face will stand out distinctly against a dark background, a dark face against a white background. But this is too simplistic. The dark face may have white hair which will lose its outline if placed before a light sky. Or the light-faced individual may be wearing a dark suit which again will be lost against a dark background. In this case a change of clothing can be the best solution, unless you are actively seeking the stark dramatic portrait where all surrounding detail disappears to leave the face standing out in a sea of darkness. The point is, these juxtapositions must be very much in your mind when you start the photographic session and seek out a location. As a rule, the simple uncluttered background will allow the viewer to concentrate his attention on the subject. Outside, the most uncluttered background is probably a clear sky. If the white tones of the sky are too bland, you can always add a yellow, or even an orange filter to heighten contrast between face and background. But remember that a filter is only at its most effective when the sun is directly behind you. A wonderful and dramatic moment for portraiture is when the sun breaks through after a storm and the sky is still dark and foreboding.

Portraiture by daylight is very much a matter of controlling contrasting light conditions. The human eye is able to see detail in light and shade far beyond the capabilities of the photographic process. Learn to look out for light-reflective surfaces. Shooting from shadow into sunlight would usually cause a straightforward silhouette but in this picture the light surfaces have produced some detail in the figures.

Kodachrome 64, Leica 35mm, 1/125th sec @ f4

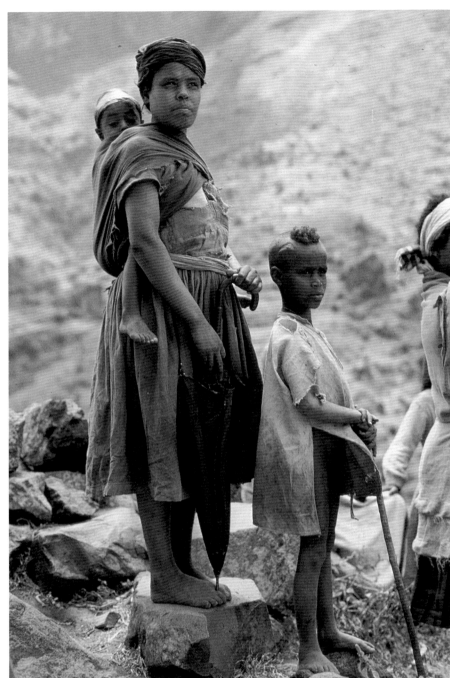

Open shade produces ideal conditions for detail in tone and colour. This picture was taken when the sun disappeared briefly behind puffy white clouds which scattered and softened the light. These hillside people of Ethiopia were quiet and dignified and largely unconcerned by the camera.

Kodachrome 64, Nikon 85mm, 1/250th sec @ f4

Unfortunately these things cannot be arranged to order but you should always be aware of the changing possibilities. The uniform, dark background outdoors can usually be found in a shaded spot, probably under a group of trees. I always have in mind the open door or window which will give me the necessary black background.

The Inverse Square Law

The inverse square law states that by doubling the distance between a light source and the subject you quarter the surface illumination. The fall off in light is far greater than seems apparent to the human eye and we are easily deceived as to the relative light values. Experience, and the many unpleasant surprises along the way, do help your judgement but it is worth remembering this lighting phenomenon. An object four times further removed from the light source than our sitter will need 16 times the exposure. Opening the lens by 4 f–stops is equivalent to 16 times the exposure (you double the exposure with each f–stop). At 4 times the distance, therefore, you would have to open the lens 4 f–stops for correct exposure. A ratio of twelve to one is perfectly acceptable to the human eye and we can register detail in the shadow as well as the highlight areas (or the brightly-lit foreground and the darker background). Negative film, and more so the resulting photographic paper print, does not have this ability.

To return to the open door or window. Here the light ratio is so great between the outside and the interior that even the human eye may have difficulty picking out inside objects. You can be assured that you have as black a background as if you had hung up a black velvet backcloth. If you decide to go inside the house you must be prepared for the longer exposures that daylight photography indoors entails. Have a tripod, or at the very least a unipod, with you. The window now becomes the primary light source. By varying the angle at which you pose the sitter in relation to the window, a whole range of different lighting arrangements will become apparent. The most straightforward will be the sitter facing the window full face. No problem of lighting here. As the face is turned through the 90 degree angle,

so the modelling increases and the shadow area takes over. Now you will need to use a reflector to get the right balance between the highlight and the shadow area.

Softening Daylight

A reflector can be anything from a piece of white cardboard, or a sheet of polystyrene to a silvered collapsible 'flat' umbrella and stand. The latter is an inexpensive item but well worth having as it is so readily transportable. Probably the most ingenious reflector on the market is the Nastolite. A piece of white nylon is stretched taught within a circular metal rim which collapses easily to fit into a frisby-sized pouch. It is very light and easy to hold or prop up but the reflector and stand still has the advantage in that it can be very accurately positioned.

As you retreat further into the room, so will the light become softer and more diffused. The background which is very likely cluttered and distracting, could now become a problem for two reasons. The lighting ratio has been reduced and the background has become more in focus. The figure no longer stands out so distinctly from its surroundings. Another way to soften daylight would be to hang a net curtain over the window or, if the space allows it, to place the sitter more to the side of a window rather than directly in front of it. Where room lighting consists of opposite sets of windows, the shadows can be lightened and the portrait softened without the need of a reflector. An even better situation is where you have windows in adjacent walls, as long as there is sufficient space between the two sets of windows. By posing your sitter closer to one window you can use the other window as fill-in light. To create a more directional lighting you could also black out the lower half of the window which is the main light source for your portrait. This will have the effect of casting downward shadows which improve the modelling in the face. Care must be taken in the cases of persons with rather deep eye sockets, in which case lack of light on the eyes would make this lighting variation inappropriate. In a compelling portrait, it is so often the eyes which engage us directly into a person's being. In normal everyday

situations you cannot look at someone straight in the eyes without its being suggestive or rude. Yet in the portrait situation the camera, and through the camera the viewer, is uniquely privileged to look at the sitter straight in the eye. To me that direct eye contact is so often the essence of a good portrait. Always be aware of the lighting especially as it affects the eyes, although their expression will only come about by the rapport that you succeed in establishing with your sitter.

A person looking out of the window in profile can give a very effective portrait with the beautiful natural rim light that this situation creates. The inevitable closeness of the background may be intrusive in which case it is just as well to take a small backcloth along with you. In a way though, I feel this defeats the purpose of the daylight portrait, which, posed though it may be, still aims for a naturalistic feeling with some reminder of the environmental, the everyday, in it. It is fairly easy, if a little cumbersome, to put up a suitable backdrop. A more creative approach would be to use the haphazard items around the place in an abstract way as components of the photograph. They may work well in terms of contrast, light and shade and yet must not intrude as objects in their own right. Generally I find that rounded objects, such as vases and lamps, are no problem when rendered out of focus. Angular shapes, on the other hand, such as door frames and pictures can still be intrusive, however unsharp. It is usually a very simple matter to remove a picture from the wall. Do not hesitate to do so. Some photographer was quoted as saying that 90 per cent of photography is moving the furniture. It can certainly seem like that at times, particularly with the environmental portrait where the objects are an integral part of the picture.

One possibility that remains is the total silhouette. Place your sitter between you and the window but take great care with the exposure. Overexposure will result in diffusion of light along the rim of the silhouette. Underexposure will leave the silhouette grey and washed out. A close-up light reading of the forehead is the most accurate method of measuring the correct exposure.

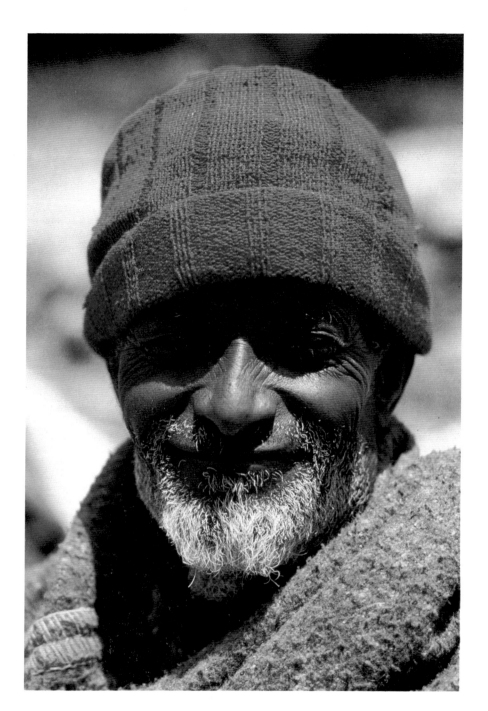

A typical midday picture in the African sun. The contrasts in light and shade are too great for the film to encompass with the result that the eyes appear like two black holes. Nevertheless the splendid red woollen hat and white beard have managed to redeem the picture from the 'out' tray.

Kodachrome 64, Nikon 85mm, 1/250th sec @ f5.6

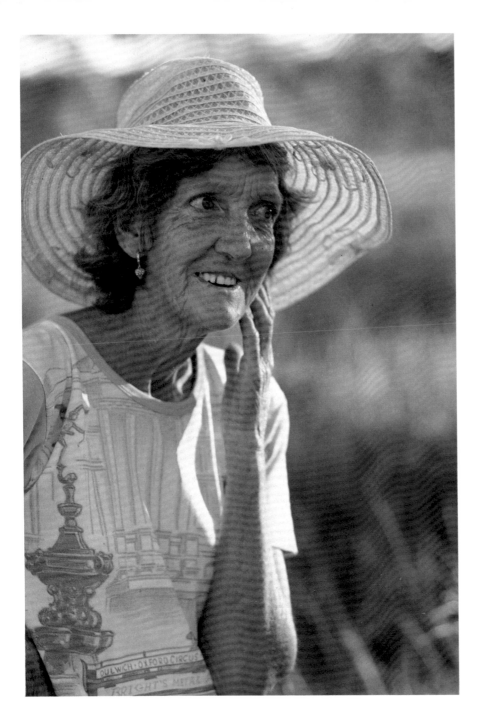

These two pictures were taken within ten minutes of each other but are different in mood and effect; all I have done is change my position. In this one I make use of reflected light. The rays of late evening sun have been diffused through the woman's white cotton hat. Added to that, the surface behind me reflected light into the woman's face to give plenty of detail in the skin tones.

Kodachrome 64, Nikon 85mm, 1/125th sec @ f4

This man was prospecting for gold, when I came across him at sunset in the Australian outback. I positioned myself so that he obscured the direct rays of the sun from my camera lens and observed this etching of light around him. This is the ultimate in contrast—the rim-lit picture, almost a pure silhouette.

Kodachrome 64, Nikon 50mm, 1/125th sec @ f2.8

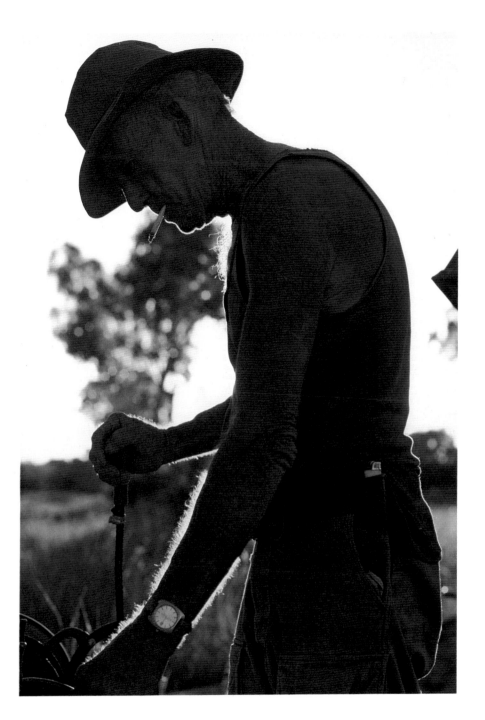

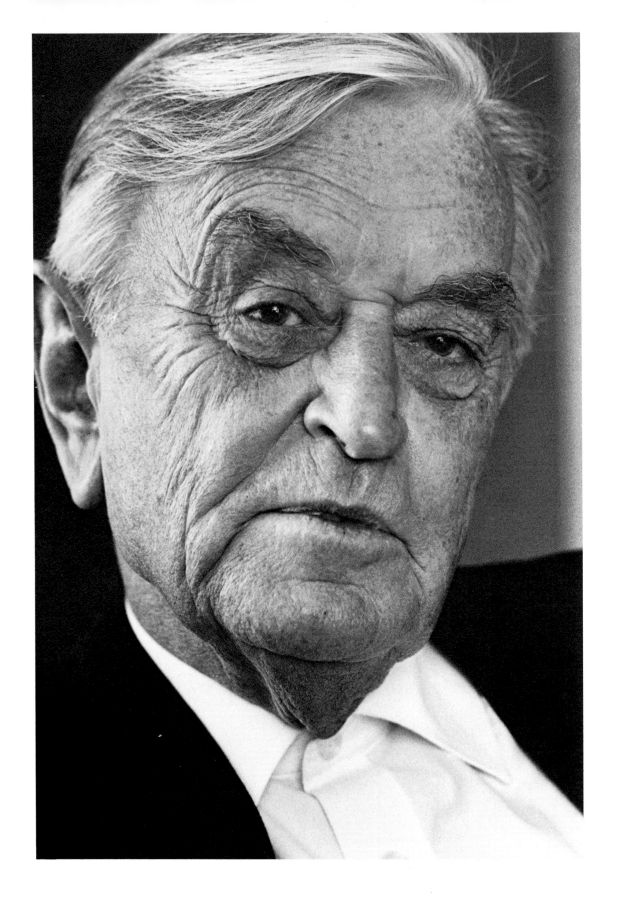

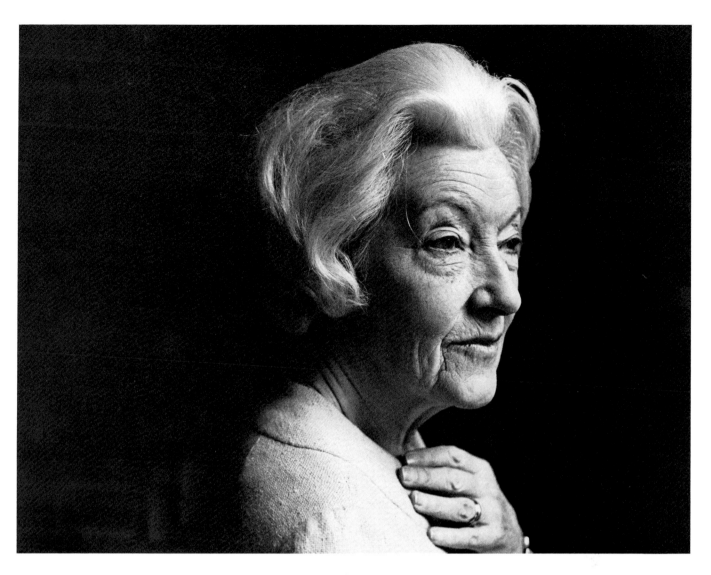

Dilys Powell, the film critic, photographed close to a window in her room. The weakening of light away from its source (inverse square law) means that the background is so underexposed as to be rendered black. I had no need to worry that objects in the room would distract from the portrait and was lucky that Miss Powell had such lovely white hair to give added contrast. This type of lighting may not work so well if someone has dark hair which disappears into the background.

Kodak Tri-X, Leica 35mm, 1/60th sec @ f2.8

Facing page: **Film director Sir David Lean. Indoor daylight from two sources gave good modelling to the features.**

Kodak Tri-X, Nikon 135mm, 1/30th sec @ f8

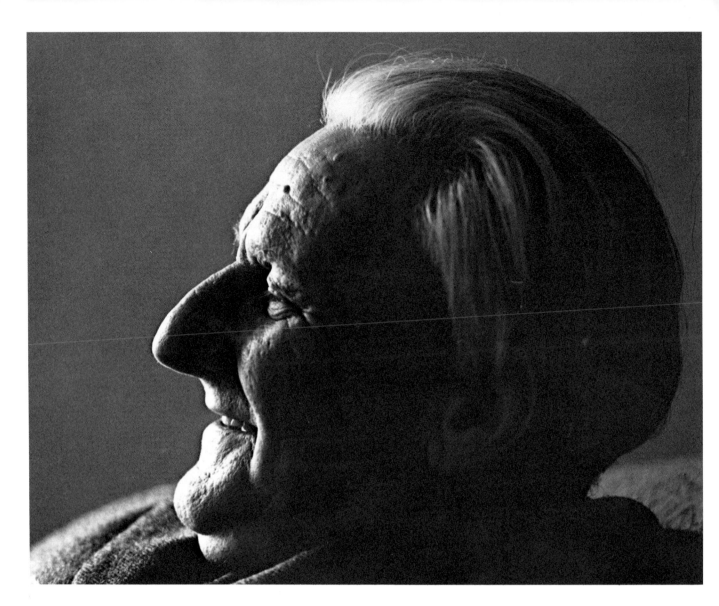

A profile is likely to appear very static
where you have to ask someone to face
a blank wall, but in this case the poet
Edmund Blunden was being
interviewed, which helped me to get a
lively expression. Removing a picture
from the wall, enabled me to obtain the
even, grey background.

Kodak Tri-X, Pentax 135mm, 1/125th sec @
f4

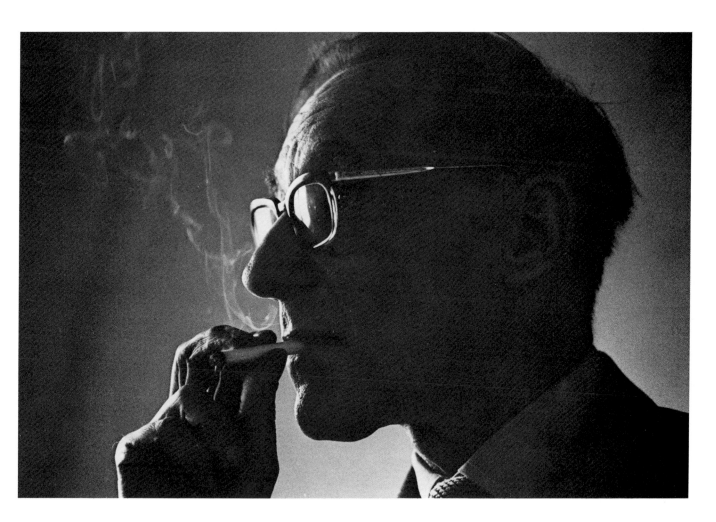

Reflective surfaces such as spectacles may cause problems unless you can make a feature of them in their own right. In this portrait of author William Burroughs, the reflections add an air of mystery and pensiveness which is intensified by the wisps of cigarette smoke. This will only show up well if you photograph against the light.

Kodak Tri-X, Nikon 85mm, 1/60th sec @ f4

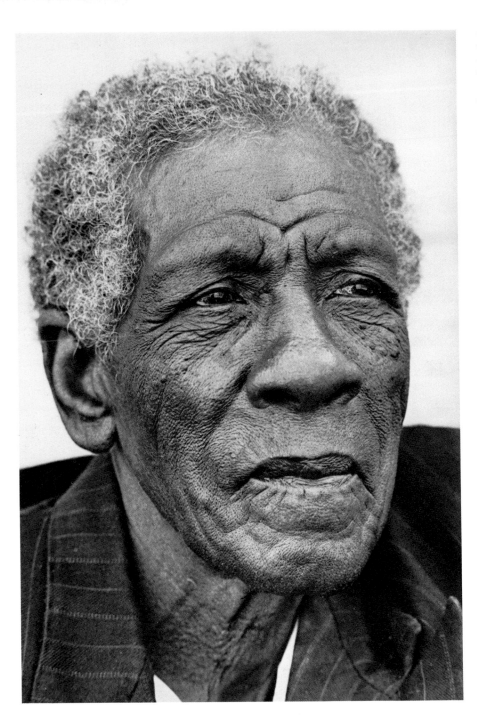

Left: **Skin textures are clearly defined in this portrait taken in bright open shade. Ample exposure with dark skin brings out the detail even better.**

Kodak Tri-X, Nikon 105mm, 1/250th sec @ f5.6

Facing page: **This bust of Robert Graves was so lively (as was its creator) that I decided to photograph the two as if in conversation. It was an ideal subject for a silhouette. Calculating exposure is always difficult for subjects of extreme contrast such as this. Overexposure will cause diffusion along the outline, whereas with underexposure the background will go grey. There are two suitable methods to use:**
1. Take a reading of the unlit figure and then of the background and expose between the two.
2. Take an incident light reading at the subject's nose at 90° to the camera.

Kodak Tri-X, Nikon 50mm, 1/125th sec @ f4

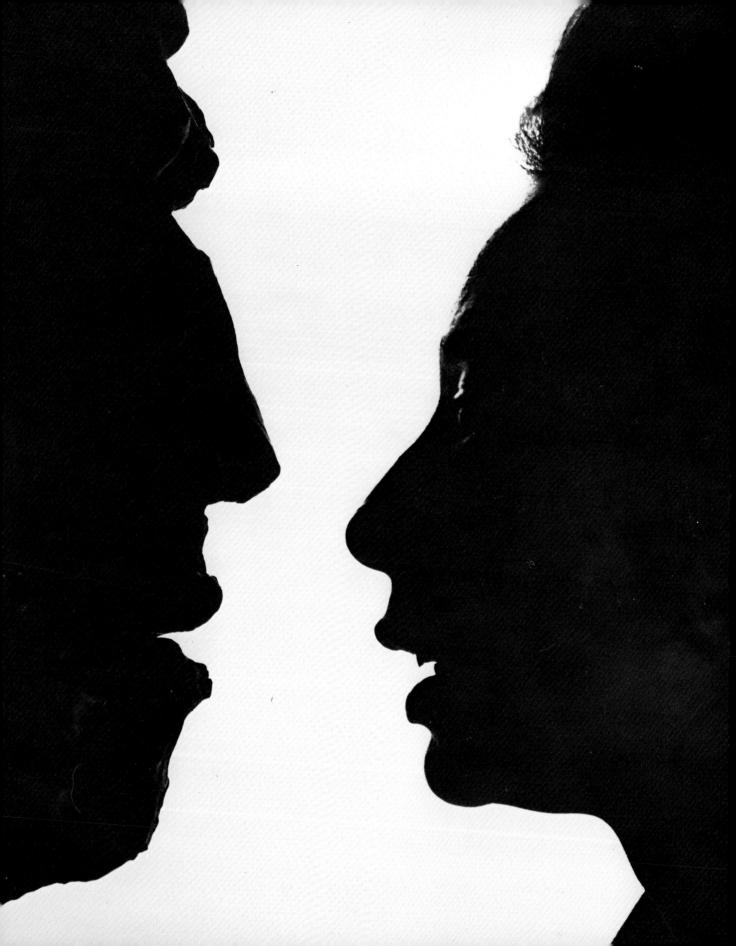

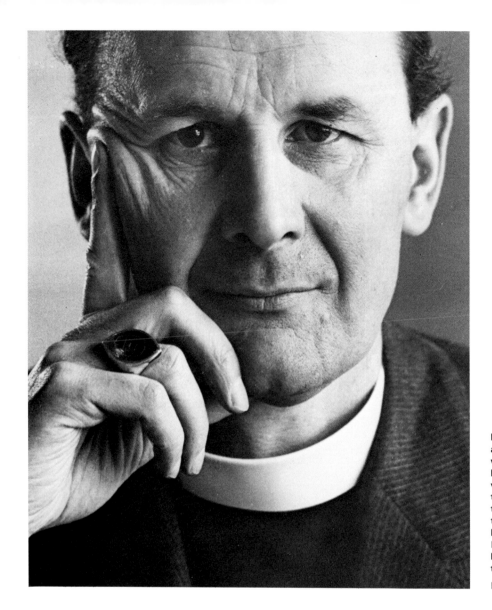

I photographed the Bishop of Woolwich at his home by daylight. The situation was ideal for this type of portrait, with light coming from two opposite windows. I placed him at an angle close to the main window, used a white board to lighten the shadow and was pleased to see how the second window added highlights to the shadow side of the Bishop's face and hand. By cropping the head, all attention is concentrated on the forceful, intelligent gaze of the eyes.

Kodak Tri-X, Pentax 135mm, 1/30th sec @ f8

Lighting

Daylight is the most varied, the most pleasing and the most subtle form of lighting. Its variations are endless and we can learn endlessly from it in our understanding of light, shade, texture and contrast. It is derived from one point source fixed in time—the sun. That basic concept is the important thing to bear in mind when you start to use artificial light in portrait photography. An elementary mistake in lighting a face is to use one light on the right-hand side and then use an equal light on the left-hand side, to lighten the shadows created by the first light. The result is not just flat but confused with crossed shadows on either side of the nose.

The effect you want to create is that of sunlight diffused by white clouds, with shadows lightened by reflective surfaces. This simple, pleasing form of lighting is the basis of the well-lit portrait photograph. It requires a key light above and to the side of the face and a reflector to lighten the shadows. Where a reflector would have to be placed close to the face in order to lighten the shadows sufficiently, it might then intrude in the picture. A more controllable way to lighten the shadows is to place a diffused frontal light as close as possible to the camera position. This second light, or fill-in light as it is called, would be between half and one third of the power of the key light. Alternatively, for the same effect you can place an equally powerful light further from the subject. Used on its own, the fill-in light would have much the same effect as a flash fired from the camera position. That is to say, flat, harsh and with only a rim shadow. It is the key light which creates modelling and depth to the portrait.

This method of using light is very understated. It allows the photographer to concentrate on all the other elements that go into making a successful portrait.

There are times however, when the lighting itself may be the prime feature of the portrait. Arnold Newman for instance, the famous American portrait photographer, is normally very understated in his use of lighting. In 1963 however, he photographed the German industrialist Alfried Krupp in his Essen factory. By using two low lights on either side of the figure, no fill-in and harsh shadows, Newman, through his use of lighting, was clearly able to portray the element in his sitter's character that he felt strongly about. The lighting has been used in an unconventional way but with a clear purpose in mind—to reveal character. Too often lighting effects may be dazzling but they do nothing towards revealing the character of the persons portrayed.

Lighting with Tungsten

In recent years flash as a lighting source has advanced in leaps and bounds. It is now the most generally accepted means of artificial lighting. Its advantages are numerous and I will return to them later in this chapter. The great advantage that tungsten lighting has over flash is in visibility. You can see exactly the effects you are creating. As a beginner in the field of portraiture you will be able to control the results with a greater degree of certainty. The experience that you gain by working with tungsten will be a great advantage should you decide at a later stage to work with flash.

Lamp Holders

Your first consideration in equipping yourself for portraiture will be the nature of the lamps you require. If your intention is to create a home-based studio set up, then floodlights with their large range of reflectors to vary the quality of light will give you great versatility. Your basic requirements will be two differing types of reflector. The one to be used as the key light, should be a bowl of medium depth with a matt silver or white reflective surface. This is the most common type of flood light available on the market. If you can afford it, buy two of them. One to be used as your key light, the other for the background. The light to be used as fill-in should be wide and very shallow with a white reflective surface. A small metal disc can be suspended in front of the bulb to prevent any direct light reaching the subject. The effect is to diffuse the light still further. These two lights will cover basic portrait requirements.

For special effects you will require a spotlight. These can be fairly expensive as they incorporate a lens to cause the light to travel as a narrow beam. By varying the distance between bulb and lens, the width of the beam may be adjusted. A partial spotlight effect may be obtained with a highly-polished deep-bowl reflector. This light is suitable for highlighting the hair in a portrait or lightening specific areas of the background. It is considerably cheaper than the specialised spotlight.

Photofloods

There are two photofloods which can be used with these reflectors. The No. 1 burns for roughly three hours and produces 500 watts. The more expensive No. 2 burns for 10 hours and produces 100 watts. Unfortunately they burn at a colour temperature of 3400 Kelvin. This balances with Kodachrome Type A colour film which has been discontinued in this country. The available Type B colour film is balanced at 3200 K and if used with photofloods will produce in a rather cold, slightly blue colour cast. With black and white film of course, the colour temperature of the bulbs is of no concern and will not affect the end result in any way.

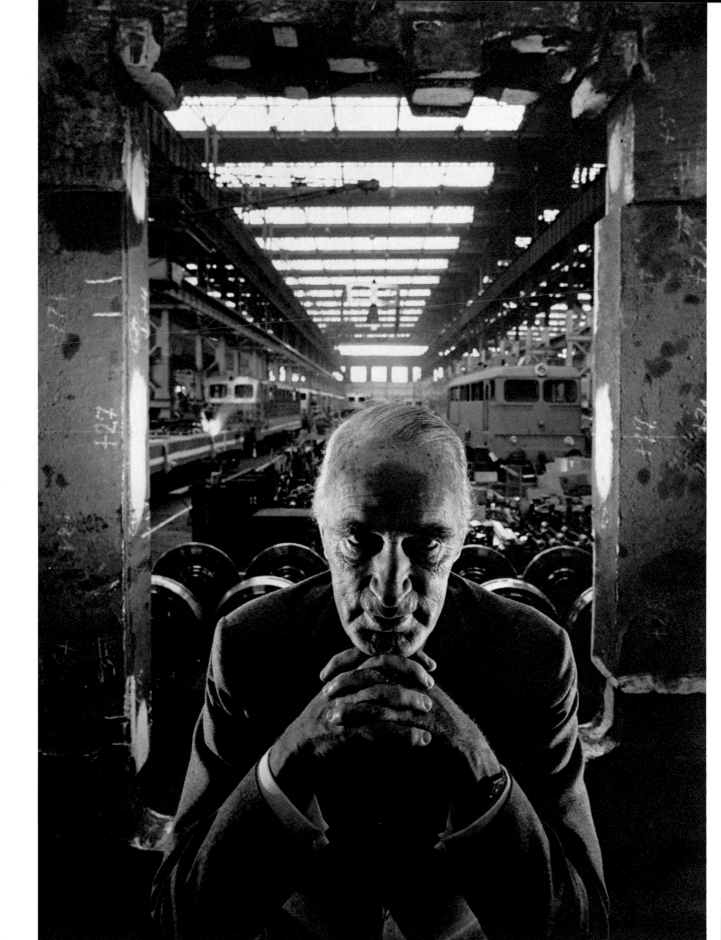

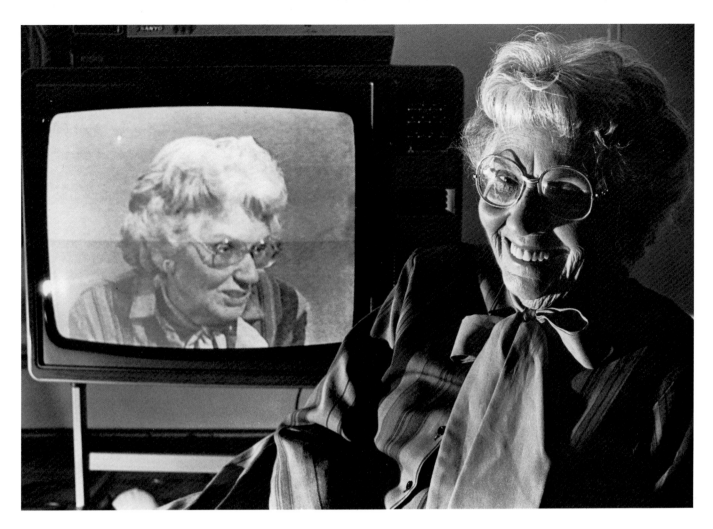

Another example of the controlled use of lighting. Creating the impression of a face lit by a television screen or glowing fire needs careful control. Too much light will kill the intended effect, where too little will leave the features in darkness. This picture of Mary Whitehouse succeeds and adds a sinister touch of its own.

Photograph Mark Ellidge

Alfried Krupp photographed in his Essen factory by Arnold Newman. By this simple but very effective use of lighting, Newman has revealed that aspect of character which he considered relevant.

Photograph © Arnold Newman

Halogen Lights

An increasingly popular type of tungsten lighting is the Halogen tube which is balanced for Type B colour film. These are fairly expensive and delicate, so handle them with great care. They last over one hundred hours, are very powerful and are used with extremely light, compact, easily transportable reflectors, making them ideal for location work. The reflectors also come in various designs, from spot to diffuse, but overall the light is harsher than the photoflood light. To overcome this harshness, the Halogen light when used as a fill-in may be bounced from a wall or light-painted surface. Hanging a large roll of tracing paper in front of the lamp is another useful method of softening your light source. Care must be taken here as the Halogen lights burn at an extremely high temperature which could easily ignite the tracing paper if it is placed too close to the tube.

The Supremacy of Colour

Colour photography has become the universally accepted medium among amateur as well as professional photographers. The one area where black and white still predominates is in the national press. Here the quality of colour reproduction on cheap paper with fast running presses is still not acceptable. Bad black and white reproduction is not nearly as aggravating as bad colour. The newly launched *Independent* has shown the way forward in terms of quality by printing small runs in several distribution centres. Consequently the presses are able to be run at far slower speeds and this greatly facilitates quality control. At least they have shown that a high standard of black and white photographic reproduction is possible in the national press. My only fear is that in the future the same improvement could occur with colour. Black and

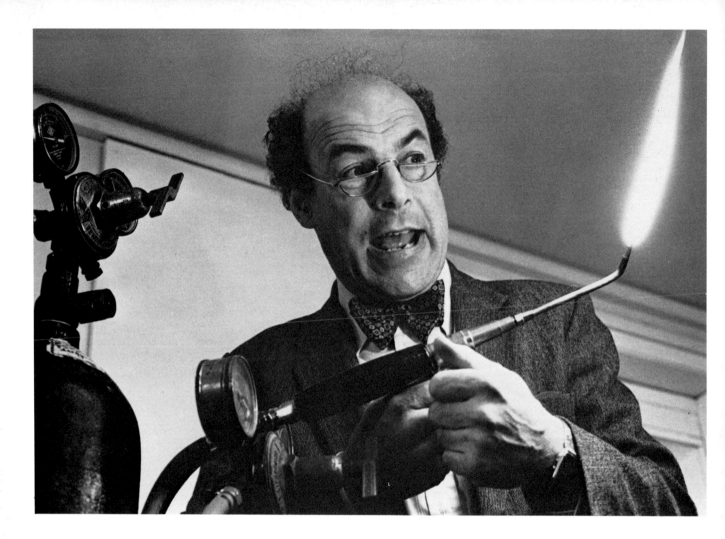

white as a medium still thrives for the very reason that it is so widely used in newspapers. If that outlet followed our magazines into colour, the good black and white photograph would become a rare specimen. As it is, the scales are weighted against the photographer who works in black and white. Processing laboratories concentrate almost exclusively on colour work and even the purchase of black and white films is now confined to the specialist photographic stores.

Lighting with Flash

I mention all this in order to emphasise the great advantage that the flash alternative offers to the photographer working in colour. The light produced by a flash tube has the colour temperature equivalent to the midday sun which means it can be used in conjunction with daylight. Consider the quite frequent situation where you are taking

a daytime portrait in someone's home. With tungsten lighting, curtains would have to be drawn to be sure that no daylight affected the result by changing the colour balance. With flash the very opposite. You might even make a background feature of the view through the window or use flash as a fill-in for a predominately daylight portrait. On the other hand, the tungsten light from a small desk lamp in the background will reproduce quite acceptably on daylight film, adding atmosphere to the picture. We accept the preponderance of yellow with which daylight film reproduces tungsten light more readily than the overly blue cast produced when using Type B film in daylight.

Flash has other advantages over tungsten. It is brief and very intense. The flash duration is between 1/750th and 1/2000th of a second and size for size it is capable of producing more light than a tungsten light. Camera shake is

Above: **One of those occasions when an element in the photograph also acted as the main light source. I wanted to portray Heinz Wolffe as the mad scientist and got him to play around with an oxy-acetylene burner.**

Kodak Tri-X. Nikon 35mm, 1/60th sec @ f5.6

Facing page: **Mixing light sources can cause problems if you are shooting in colour. Flash is balanced for use with daylight film. In this picture of Trevor Nunn at the Barbican, his face is in shadow. Had I used a tungsten lamp as fill-in, the results would have been far too yellow. 'With flash correct colour balance is achieved though slight warming of flesh tones with an 81A or CC10Y gelatin filter generally gives a more pleasing result.**

Kodachrome 64, Nikon 24mm, 1/125th sec @ f11, CC10Y filter

therefore never a problem with flash pictures and a flash picture is always apparent for its crispness. Although shutter speed has no influence on exposure, when taking flashlight pictures it is necessary for the shutter to be fully open at the moment that the flash is fired. There are two different types of shutter—the focal plane and the compur. 35-mm cameras all have focal plane shutters incorporated in the camera body, whereas larger format cameras use compur shutters which are positioned between the front and the rear element of the lens. With compur shutters, any shutter speed can be used to encompass the duration of the flash up to 1/500th of a second. Most focal plane shutters cannot be used with a shutter speed faster than 1/125th of a second although there are now focal-plane cameras on the market that can go up to 1/250th of a second and still illuminate the whole picture area. At faster shutter speeds you will find that a substantial part of the negative remains unexposed as it was covered by the shutter blind during the flash exposure.

A sitter is likely to be less disturbed by the intermittent flash than the heat and glare of tungsten light. Another advantage is the way the flash may be triggered by a photoelectric cell or 'slave unit' as it is known. This means that as one flash is fired by releasing the camera shutter, all the other flash heads will fire simultaneously without any need to wire them individually to the camera. You can place small lights in all sorts of nooks and crannies without the problem of tell-tale cables to hide, as would be the case with tungsten lighting.

Hand-Held Flash

The small hand-held flash units that can be operated from a 'hot shoe' on the camera or a bracket to the side of it, are ideal for the portrait photographer who is on the move and working primarily on location. Although I would rarely use the camera as described above, that is to say directly from the camera, these small flashguns are surprisingly powerful. Powerful enough to use as a reflective power source and 'bounced' from a wall or ceiling. With colour this may not be possible unless the room is white. Any other room colouring will cause a colour cast in the photograph. A large white umbrella is an ideal shape and surface for reflected light and has become the most universally used light source in portraiture. It gives a soft,

diffuse and very pleasing light which can be varied according to the surface. A silver-coated umbrella will give harsher shadows. A gold-coated umbrella will warm the flesh tones for colour. An umbrella which is white on the inside but black on the outside will give less diffused light than the more generally used white, slightly transparent umbrella which reflects 70 per cent light but transmits 30 per cent to lighten the room generally and further diffuse the shadow areas. By turning the umbrella around it can now be used much as a light box, to give a weak directional light. The sort of light that simulates the glow from a fire or the light picked up on the face of someone watching a television screen.

The Auto-Thyristor

Most of the small battery-powered flash guns now on the market incorporate an auto-thyristor cell or 'electric eye' which measures the light output and cuts off the light when the selected output has been reached. A green bulb lights up to let you know if the light level is attainable. If the flashgun is incapable of generating enough power, the failure of the green bulb to light will warn you of this. The great advantage of this type of gun, apart from the delight of automatic exposure control, is that by using a large f-stop you cut the light output to a minimum. This enables the flash to recycle almost instantaneously, fast enough to be used in conjunction with a motor drive. When used with an umbrella however, you would need the full flash available and the recycling times will be too long, 6 or 7 seconds, to catch the fleeting expressions in a portrait. For this reason, some manufacturers have developed a battery power pack which when used in conjunction with their flashgun, will cut recycling times to a minimum. When purchasing a flashgun it is well worth considering such a system. The power pack is a fairly expensive item. If you have purchased the appropriate flashgun, it can always be added at a later date. Sunpak is the system that I have found to be the most versatile. In order to make use of the electric eye for automatic exposure control, it is essential to have a fully revolving flash head. You reverse the flash head to fire into the umbrella but the electric eye is still facing and taking its reading from the subject. Woe betide the photographer who sets up his flash so that the electric eye is measuring its

required light output from the middle of a white umbrella barely one foot away. I speak from experience!

Studio Flash

Where you would wish to use slow-speed, fine-grain films in black and white and especially in colour, the small flashgun described thus far is not really suitable. You will be limited to apertures of f2.8 or f4 giving you a very limited depth of focus. The more powerful studio flash comes in two basic forms: the self-contained power pack with lamp combined, and the separate console which can power up to six separate heads. They both come with modelling lights, which is another considerable advantage with this type of equipment. Now you can tell where the shadows fall. The flash is about ten times the intensity of the modelling lights and many photographers still like to check their lighting with an exposure on polaroid instant film. The studio flash can be fitted with numerous accessories to control the light source. Most interesting are the 'honeycomb' devices which concentrate the light into beams of various widths, according to the type of 'honeycomb' used. Similar to a spotlight, they are much cheaper and lighter for location work. The individually-powered studio flash heads are still light and compact enough to be used on location. The umbrella and light stand fold away easily into golf-bag-type canvas bags and the lamp heads can be carried in custom-built cases.

Studio flash with coloured gel holders and honeycomb attachment.

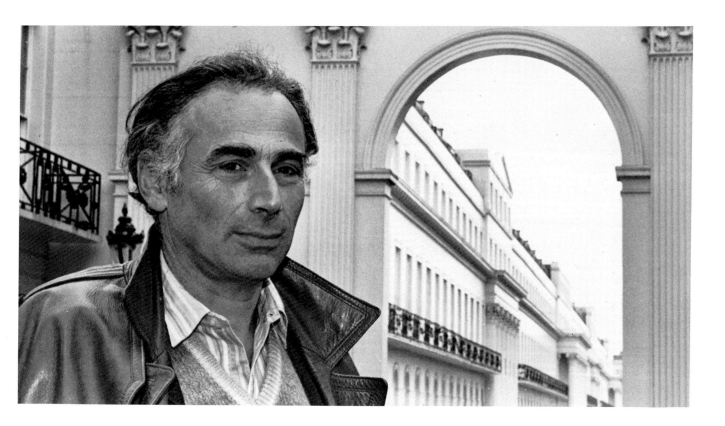

The small flashgun operated from the camera can be used to brighten a face in such a way that its use is not too obvious. I set the automatic eye at two f-stops below the ambient light reading. That is to say, with an exposure of 1/125 @ f11 the flash is set at f5.6. This portrait of writer Frederic Raphael manages to add enough light to his face without intruding on the natural daylight.

Kodak Tri-X, Nikon 50mm, 1/60th sec @ f8, flash set @ f4

Flash Exposure Control

Studio flash does not incorporate the electric eye exposure control which is not quite as foolproof a way of measuring exposure as the individual flash meter. The flash meter is plugged into the flashlight on a long cord. You hold it in the same manner as an incident-type exposure meter at the subject's face and facing the light source. The meter triggers the flash by an electric impulse and takes an instantaneous reading. This may be in the form of a calibrated needle or the more modern LED display.

Calculating Exposure

Correct exposure is what we all seek in our photographs but it does mean careful use of metering. The built-in exposure meter that is incorporated in most modern SLRs has been discussed in a previous chapter. I have indicated how its shortcomings may be overcome. Treat it like a hand-held meter and take a close-up reading from your subject. Where this is difficult, the alternative method is the use of a long focal length lens to give you a chosen area reading. With these two methods you may never require a hand-held exposure meter

though for easy handling and as a double check, the separate meter is certainly an item worth having.

The most accurate method of calculating exposure is with an incident-light meter or a spot meter. The first measures the light falling on the subject, where the second can be aimed through a viewfinder at any specfic area, from the lightest to the darkest. Correct exposure can then be calculated by taking an average between the two extremes. If the ratio is greater than 4:1, that is to say over two f-stops between shadows and highlights, then detail can no longer be rendered in both areas. You will have a choice of lightening the shadow area or exposing for the highlights, according to the effect you are after. A typical situation of extreme contrast when correct exposure is difficult to ascertain, is the silhouette or the rim-lit photograph. Expose for the shadow area and the outline of the silhouette will become blurred due to the overexposure of the background. Expose for the background and an overall greyness will be the result. I have found the most accurate exposure reading by holding the incident-light meter by the person's profile at 90 degrees to the camera.

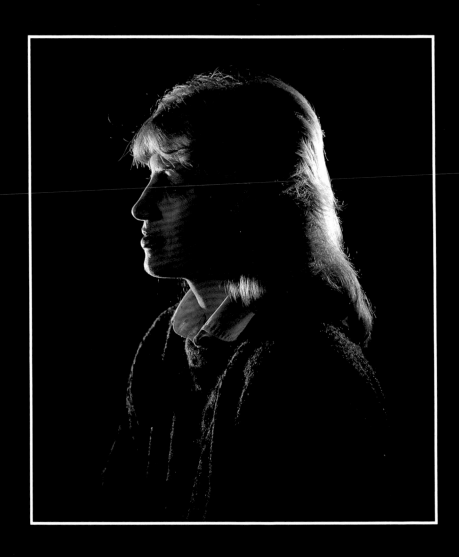

Rim lighting lit with studio flash. The exposure was taken with flash meter held at the subject's profile at 90° to the camera.

Ektachrome 100, Mamiya 6 x 7 180mm, CC10Y filter

The Portrait Session

The Portrait Session 1

Before you start the session, one thing has to be crystal clear in your mind. What is the purpose of the photograph? If you are taking a portrait commissioned by the sitter, then his considerations have to be taken into account. If he is not pleased with the result, your source of commissions will quickly dry up. People do have idealised notions of their own appearance. You will have to use lighting and camera angle to try and bring out the most flattering aspects of their features.

On the other hand, where you are commissioned by a magazine, your thoughts will be concentrated on the impact of the photograph itself. Whether your subject is happy with his or her appearance is really a very secondary consideration. As we have seen with the Arnold Newman photograph of Krupp, you may be seeking the very opposite.

I decided to start this chapter by interviewing two photographers who approach their subject in quite different ways but who are both very experienced and successful in their respective fields.

The High Street Photographer

Brian Parry has run his own studio in north London for some fifteen years. At the time that he started, the High Street portrait photographer was very much on the decline. With the advent of cheaper materials, cheaper processing and foolproof cameras, the product that the portrait photographer offered was no longer good enough. And so, the Rembrandt technique was evolved. If photography could look like a painting but retain the essential quality of perfect likeness, it was on to a winner. The basic ingredients are classical poses, filters and printing the chosen enlargement on canvas. Brian Parry has a Hasselblad

with a 150-mm lens, for head and shoulders and an 80-mm lens for full-length or group shots. Then he has a Softar soft focus filter, on top of a neutral density vignetting filter which very slightly darkens the surrounds of the portrait. The lighting is very straightforward and consists of two umbrella flash heads. A key light at 45 degrees and three feet above the sitter with a fill-in at half the power (or twice the distance) on the same side as the key light but more to the centre. Sometimes a spot will be used from behind to highlight the hair.

The small 20 x 12 studio is painted dark brown to allow maximum lighting control, although some photographers prefer the side walls to be white up to the point where the customer will be seated. This has the effect of lightening the shadow on the nose without causing unwanted lightening of the shadow area on the side of the face. The backdrop is brown-painted canvas in a mottled fashion to give some variation in tone to the background. A variety of stools, steps and a miniature couch are readily available to vary the poses. And this is where Mr Parry becomes animated, because knowing your poses is what it's all about: 'As the years go by and you do more portraits, so you learn more and more poses. You also note what other photographers have done—it may be a portrait photograph or it may be a picture in *Vogue*—so that your style at the end of the day is a melting pot of all that you have seen and the bits that you've liked and the bits that you haven't. It is unlikely that you will get many Michelangelos around who are totally unique and spontaneous in everything that they do. Fifteen years ago when the Rembrandt style of portrait photography was first introduced into this country from America, all the portrait photographers were down the

Portrait Gallery every other week studying all the different poses.'

The length of time allowed for a portrait session is 45 minutes though this may be cut to 30 minutes in the busy season. Mr Parry meets his client and they briefly discuss the type of picture required. The portrait a boy friend would appreciate will not be the same as the one for parents. Photographer and customer have now met for the first time and the photographer prepares the studio while the sitter prepares hair, make-up, clothes etc. for the session, or just has a cup of coffee. The photographer having assessed his subject, now arranges the lighting, sets up the appropriate settee, stool or chair, loads his camera and checks exposure for the pose he has decided on. Broad lighting, that is frontal with no shadows, tends to look better for a black person whereas a wide round face can be made to appear narrower by using strong side lighting and pronounced shadows.

'Never take a customer into the Studio and then start fiddling about rearranging the background and changing lights, because it gets them very fidgety' he advises. 'The important thing is that people have confidence in you, so you must appear to know what you're doing. There is nothing worse for someone if they come in and you say "we'll try that . . . no that doesn't quite work, just move that hand . . . no, no, move your head, no" People think "what's this bloke doing?" The first thing I say is "don't worry about the poses or how I want you to sit. I'll show you all the poses. Don't worry about the expressions, just leave it all to me". The photographer is in total control—the sitter about to be moulded into whatever role the photographer feels appropriate—demure girl, angelic child, caring mother or debonair young man. The composition will conform to one of three tried and tested

Portrait Photograph Brian Parry.

shapes—triangular, oval or diamond, long beloved by the traditional portrait painter. At this point he will make the fine adjustments, cuffs, tie, ear rings, everything has to be perfectly in place before he can turn his attention to coaxing the required expression from the sitter. 'It doesn't matter how perfect the portrait, the person always chooses the one where the expression pleases them,'' Brian Parry told me wistfully. I had a feeling that his masterpieces were not always the ones that sold and I felt a kinship. A newspaper photographer's favourites so often get overlooked by the Editor.

The Magazine Photographer

Whilst working on this book I was struck by a portrait that appeared in the colour section of the *Sunday Times*, to go with an interview by Susan Crosland. The subject was Carlos, the King of Spain. In the photograph he seems a sensitive, quite unregal person and yet his surroundings are suitably grand, without in any way imposing on the picture, to let you know that here is a person of some power and authority. The pose is comfortable and yet slightly stylised. The pose of a man saying 'I know this position suits me.' He is a man

The King of Spain Photograph Peter Marlow.

obviously used to having his picture taken. But what really struck me was the lighting—a shaft of sunlight seemed to have fallen on the King of Spain's face and very fortunately picked out his hands as well. Natural rays of sunshine are not so obliging, so I knew the picture had been lit with some expertise.

The photograph is by Peter Marlow, a photographer known for his documentary pictures from all over the world. He is a member of the famous Magnum group of photographers and does a lot of his work for the *Sunday Times Magazine*. This was a different side to the pictures I normally associated with

him and I thought it would be interesting to hear his views on portraiture. Disconcertingly and, now I come to think of it predictably, he started off by stating that he didn't think of himself as a portrait photographer at all. People in their homes and places of work were what interested him but inevitably portraiture often came up amongst his assignments. Although Peter works in black and white for his own personal photography, almost all his other work is in colour. The techniques and sensitivity he uses in his portraiture had certainly been noticed by others than myself and he had just completed his

47

3rd Annual Report for the Murdoch empire, a prestigious assignment, and one which requires a great variety of portraits of the people who work in the company worldwide.

This time however, all the experience, the professionalism and the expertise had been needed for the assignment in Madrid. 'The writer and I were granted one hour and it was suggested that I should take the photographs during the interview. I thought that was a bad idea. I don't think I've ever got a decent picture that way. It is a very easy way of working—it doesn't challenge you at all. You get a good safe picture but to me it's a cop out. You haven't connected with the person.'

It was agreed therefore to limit the interview to 40 minutes leaving Peter with 20 minutes to take his photograph. This gave him the opportunity, which he likes, to set everything up in advance. If at all possible he will visit someone the day before a portrait session to see the setting and decide on necessary equipment, although almost more important would be the opportunity to observe the person he would later be photographing. The equipment he carries on an assignment like this is quite extensive: a flash system with modelling lights which is mains controlled, and a complementary one which is battery controlled. Also two small Vivitar flash units to trigger the main lights and possibly used to throw light on some isolated area in the background. With tripod, stands and cameras, it means 4 or 5 boxes of equipment and Peter usually has an assistant with him. On this occasion he had been left behind. Fortunately one of the Palace guards was happy to take on one of the assistant's roles—that is to act as model. Having selected the room and position where he wished to take the photograph, Peter now had to get the correct lighting balance. He wanted to have the background $1\frac{1}{2}$ to 2 stops darker than the subject. To get this balance right Peter needed someone to sit in for the king and a polaroid back to his Nikon camera to do the necessary test shots. He uses single beams of light, never umbrellas, and says, 'light from strobe is a very solid thing. You can introduce planes in pictures which block off light. I treat light like some sort of solid substance.' For this purpose he uses a 'honeycomb' over the strobe unit, to concentrate the light source. These come in differing mesh sizes but Peter

finds the 8-inch beam is ideal for most of his purposes. A $1\frac{1}{2}$ Tungsten gelatin filter over the strobe adds to the effect of late evening sunshine. The light on the background was ambient light and for that he needed an exposure of one eighth of a second. As he always uses a tripod in any case, to make sure the verticals and horizontals in the picture are all correctly lined up, the slow shutter speed is no problem. In fact he feels the slight softness around the eyes, if someone blinks for instance after the flash, can actually enhance the portrait.

The King of Spain did not blink. In fact he hardly had time. The interview overran and finally when he entered the room for the portrait session, surrounded by courtiers and a couple of generals, the Press Secretary informed Peter that he had at the most five minutes to get his picture. Definitely not the ideal situation for taking someone's portrait.

'It's better to be in a one-to-one situation with no people around. It sucks off energy somehow. I admire the photographer who can sit someone down in a studio and direct that person as though they were a film director and still be sensitive to what that person is and who they are and not overpower the situation totally. I have always found that very hard to do. Even asking someone to move their hands . . . You create a trust between yourself and the person and gently try to nudge them into the situation you want. I think you can get very close to someone in a very short time in that situation because you are actually interacting with them. You are asking them to do things that you wouldn't normally ask people. Sometimes you're touching them. It can be a very moving experience—whether it's a family in Kirby or the King of Spain.'

The Portrait Session 2

I have always been torn between two impulses when going into a portrait session—the spontaneous and the measured. On the one hand I will have found out something about my subject. Very often, if the person is well known, I will have seen previous pictures of them and I will have formulated some preconceived notion of the end result. Some of the decisions of camera format, lighting and location will be made prior to the session. At the same time I know how vital the accidental and the spontaneous can be to a good portrait.

I need to be constantly alert in order to

capture that moment. Too often I have missed it through apprehension or unpreparedness. The moment once lost is very difficult to recreate. So often I find that a movement which may come naturally, looks stiff and awkward when produced on request. My own answer to this problem (and it is a personal one born out of uncertainty) is to work with two cameras. One with a 35-mm lens is hand held, always at the ready, while the other is fixed to the tripod. The hand-held camera is loaded and ready as soon as I enter the room and as I leave I am still prepared for any last minute happening.

I photographed J. B. Priestley on the occasion of his 80th birthday at his Warwickshire home. I had only just arrived and J.B. was looking out of the window and lecturing me on his views on portrait photography. The only decent portrait of himself was, he claimed, taken by an Israeli photographer who worked slowly with a plate camera, hiding his head in a black cloth. These modern photographers going snap all the time had no idea . . . Whether he heard or was aware of my snap I was never quite sure. He seemed so lost in thought as he gazed into the garden and puffed his pipe. The combination of daylight from two opposite windows was perfect and there was no possibility of distortion on the 35-mm lens as the pose was in profile. Afterwards I took the more conventional birthday portrait but this early 'snap' was far more typical of the man.

The picture I took of Orson Welles was another occasion made by having the camera always at the ready. I had just finished a series of pictures taken in his hotel bedroom at the Ritz. The great man donned this enormous coat, stuffed another prize size cigar in his mouth and preceeded me down the stairs. Camera shake or not, the impressionistic glimpse is something that works successfully when your subject is well known. There is a famous portrait of Churchill taken from behind. Just the bulk and the Homburg suffice. Our imagination fills in the rest and these simple, pared-down images are graphically very powerful.

The ability to relax your subject and to make a portrait session enjoyable, as opposed to the ordeal that it is sometimes made out to be, is another element that one hopes will come naturally to you. If you are photographing people, then one of the reasons

must be that you enjoy people and are genuinely interested in them. After all a love of landscape inspires a landscape photographer and a love of architecture the photographer who concentrates on cityscapes and buildings. If you are photographing someone well known, inform yourself about them beforehand. With some lesser mortal, try and establish some common area of interest.

A word of warning here—I have got on famously with someone and still come away with a bad set of pictures. I might have been paying too little attention to the job at hand and imagined I was getting better results than in fact turned out to be the case. When I photographed the writer Philippa Pullar at her home in South London, I thought I had good pictures but the results were very disappointing. I cropped her neck awkwardly and instead of framing her face by out-of-focus shrubbery, I succeeded in producing ugly shapes and an unwanted shadow on her cheek.

When I photographed Nureyev in the mid 70s the parameters were strictly defined. Originally we had met in a West End cafe but the picture possibilities were not good and he eventually agreed that I should come to his Richmond home for a further session. The house seemed to contain mostly pairs of ballet shoes. They lined a wall of shelves in place of books. When he arrived in the room his cleaning lady appeared with yet more ballet shoes and there was some discussion. I would have loved to take some pictures then but had decided to be at my most discreet on this occasion. It was probably the right decision because at this point he announced 'we go outside!' and that was practically all that was said in the brief 15 minutes that I was allowed. He would fall into elegant and well-practised poses whenever I asked him to stand in a particular spot but grew very irritated when I tried to make conversation. 'Is this picture taking or interview?' he asked caustically.

Photographing Hands

The use of hands in a portrait may add enormously to the interpretation of character. Hands may be both unique in their means of expression and strongly indicative of a person's occupation. It is always rewarding to see the hands of a person whose profession largely depends on the use of their hands, whether it be a boxer, a painter or a musician. The likely difficulties to be overcome when introducing hands into a portrait are considerable and it is just as well to be aware of the pitfalls. Hands seem to have a way of becoming dismembered from the body and becoming detached objects. Hands are normally at waist level when sitting and this means a lot of space in between head and hand. Having an arm rest or table to lean the elbow on will bring the hands naturally close to the face. Distortion caused by a hand close to the camera will be as off-putting as an out-of-focus or overlit hand, again due to the fact that the hands are placed too far in front of the face. The overlit hand occurs particularly with frontal lighting such as window-lit portraits and it may be necessary to use a black reflector board to cast a shadow over them. On

the other hand, with a three-quarter-length portrait with lighting concentrated on the face, it may be necessary to use a separate spotlight on the hands where they are resting in the subject's lap. The relationship between bright hands and bright face will be an important compositional element in the portrait, particularly where the surrounding area is dark.

People tend to feel natural and relaxed when they clasp their hands but unfortunately the clasped hands very often come out looking like indistinguishable mutton chops. Claire Bloom solved the problem for me with her elegant and attractive 'tips of fingers' clasp. I very much wanted to show the hand of musician Sir Lennox Berkeley and with the use of a volume of music arranged the composition to allow the hand equal if not greater prominence, than the face.

Resting the face in one's hands is a very easy, natural pose for most people but it can present problems of distortion by pressure on the skin and there is also the likelihood of obscuring too much of the face. This award-winning photograph of Sally Soames' is a superb example where the inclusion of the hands has added a whole new dimension. The way Lord Scarman cradles his face seems to symbolise his care for humanity. It is the pose of a thoughtful, reflective person, whereas the hand of painter Francis Bacon is full of energy and purpose. It looks like a tool, ready to go into action.

In the portrait of Sir John Hoskyns, the hands themselves are not really a factor. They are used more to complete the pose and balance the composition. The classical statue, bottom left, was an element that exercised me more than including the hands. Sir John is Director General of the Institute of Directors, and I wanted to include some of the grandeur of the group's Pall Mall headquarters. To light the grand stairwell was out of the question. The ambient light meant a two-second exposure as I needed to stop down to f11 to get the necessary depth of focus. I placed the camera on a sturdy tripod and during the two-second exposure, fired off a flash from a position slightly above and to the right of the camera position. I underexposed the flash by one stop, allowing the ambient light to have its softening effect. Wherever possible I would bracket the exposures when using this flash fill-in technique, as the effect is

never totally predictable. Your subject should remain as still as possible during the time exposure, but the image created by the flash will remain sharp, even though a slight blur may occur with the exposure for ambient light. In fact this after blurr is an effect that photographers may sometimes over-emphasise deliberately.

Equipment Failure

Whatever techniques you intend using during a portrait session, the important thing is that they are tried and tested. If you are well versed in the technical side of things, you will be able to concentrate on the essentials of creating a portrait—the rapport you establish with your subject, the lighting set-up you wish to create and the compositional elements in the photograph. Make sure that your equipment is in good working order with spare batteries available. Nothing can be worse than the occasion I went to Covent Garden to photograph Pavarotti. The whole place was in a state of nervous tension as we awaited his arrival. Apparently he was out of humour and threatening to return to the Unites States to visit his father who was unwell. When he did eventually turn up, I was granted a brief session in his dressing room before curtain up. I had intended to use umbrella flash to balance the strong light from naked light bulbs around the make-up table. The flash didn't fire, Pavarotti exploded and with difficulty I persuaded him that the flash was a quite superfluous extra. There was no time to check out the fault. I just put the flash aside and made do with the ambient light. Afterwards I discovered the fault lay in the flash extension cable. Since that time I always carry a spare one with me.

Interview Portrait

One of the most enjoyable forms of portraiture for the photographer, is the interview portrait. Your subject is completely absorbed in conversation and you can concentrate fully on expression and camera angle. Your only chance to influence events is at the start of the interview. It is then that you must decide on the most advantageous position. If possible choose a low-backed chair that will not obtrude in the photograph, an uncluttered background and the subject facing the light if you are using daylight. One way of losing the background is to fire a flash on it from behind the subject, over-exposing by

several stops and creating a 'white washing' effect. More often a wide aperture will throw objects sufficiently out of focus to stop them intruding in the portrait. I do find the unipod a great advantage for the interview portrait. An interview may last anything up to an hour or more and the telling expression may come at any moment. To hold the camera constantly at the ready for that length of time would be very tiring. The unipod is the ideal compromise between that and the too static tripod. It allows quick movement, with the camera constantly trained on the subject, in focus and with minimal chance of camera shake.

The Profile Portrait

Never neglect the possibility of photographing your subject in profile. This can give a particularly attractive portrait, even more so when used with back lighting to highlight the rim of the profile. I was trying to show the new-look Germaine Greer in the picture used here. She had written an article for the *Sunday Times* in which she seemed to be going back on a lot of her more radical feminist views. With her hair done up in a bun, the profile was the obvious way to show her in a new, almost Victorian, light. The need to ask your subject to turn away from the camera and face a blank wall is not a very good way of getting any worthwhile expression from the sitter. Many photographers get around this problem by releasing the shutter on an extended cable release. This means they can face and talk to their subject and release the shutter by remote control, when they judge the expression to be right.

Photographing The Royals

Very few photographers ever get the opportunity of a portrait session with members of the royal family. We lesser mortals can put that possibility out of our minds. Even so, with patience, skill and perseverance, you can get good portraits on the numerous occasions when the royals carry out their public duties. Members of the press are favoured on these occasions with advantageous positions, reserved for their use, but is it still possible for the general public to get good pictures.

Recently, I needed some pictures of the Queen Mother. This was for a book I was working on and there was no chance of obtaining a Press Pass. I

decided to try my luck at the Knight of the Garter ceremony which is held every year in June at Windsor Castle. The general public line the roadway leading from the chapel to the castle and are very close to the procession as it passes them. The gates of the castle are only opened to the public two hours before the procession arrives. If you are there at the start, you have a good chance of a front row position and you know that two hours is as long as you will have to wait. People came prepared with stools and picnic baskets. I was well satisfied with my position, which, although not front row, was behind two little old ladies, who sat first row on their collapsible stools. About half an hour before the ceremony, a Beefeater indicated that all stools were to be put away. I was disconcerted to discover that the little old ladies were both nearly six feet tall and armed with instamatic cameras. I asked one of them if she would mind moving a little to the right. The response was no better than the indifference I could expect from a fellow Press photographer, jostling for position.

The Queen Mother is much loved by Press photographers. She always manages to look towards the camera and smile and give as many photographers as possible the chance of a good picture. She did not let me down on this occasion.

At other times when I have tried for close-up pictures, I have been able to use a solid tripod and long lens, in the press enclosure. With a 600-mm lens and x2 converter, you can do this over a distance of one hundred feet. A lens of this type is prohibitively expensive to buy, but you can hire it for the day at a modest fee. Many of the better-known photographic retailers have hire departments and this is an excellent way of trying out equipment that you could not otherwise afford. On the big royal occasion every available long focus lens will have been booked out, almost as soon as the date of the event is announced. For the wedding of the Duke and Duchess of York, I was unable to hire the 600-mm lens that would have been my first choice. I had to be content with a 400-mm lens and a x1½ converter. With this converter your loss of effective aperture is reduced to one stop. With a x2 converter, you lose two stops. In the event, it was a day of contrasting weather conditions and I frequently neded to use the lens at full aperture.

Nureyev in his Richmond garden. Willing to pose but not to talk.

Kodak Tri-X, Nikon 50mm, 1/250th sec @ f5.6

Phillipa Pullar in her garden. One of those occasions when a session that seemed to have worked very well, gave disappointing results. The out-of-focus foliage is ugly and the picture is cropped too tight at the neck.

Kodak Tri-X, Nikon 135mm, 1/500th sec @ f8

Orson Welles photographed descending the stairway at the Ritz Hotel after a portrait session in his room.

Kodak Tri-X, Leica 35mm, 1/125th sec @ f4

Facing page: **J.B. Priestley was discourising on the regrettable trend amongst modern photographers to keep snapping pictures indiscriminately. He disapproved, preferring the old-fashioned plate camera where, after much thought and deliberation, you made two or possibly three exposures. I half-heartedly agreed with him, but the light, the smoke from his pipe and his whole demeanour were too good to miss.**

Kodak Tri-X, Leica 35mm, 1/125th sec @ f4

Left: **Claire Bloom. I set up the picture for flash but in the end I used only the modelling lights as I wanted a wide aperture to keep the background out of focus. Flesh tones were kept light and minor blemishes to the skin eradicated by slight over-exposure.**

Kodak Tri-X, Nikon 85mm, 1/30th sec @ f2.8

Facing page: **I used a medium-format camera for this portrait of Sir Lennox Berkeley. The larger negative means greater quality and I wanted to bring out details in skin texture. Lighting was from an east-facing window with a reflector to lighten the shadow area, which was particularly good in modelling the hand.**

Kodak Tri-X, 6 x 7 Mamiya 110mm, 1/8th sec @ f11

Francis Bacon photographed using only daylight indoors.

Kodak Tri-X, Nikon 50mm, 1/60th sec @ f4

Sir John Hoskyns—a mixture of flash and ambient light.

Kodak Tri-X, Nikon 50mm, 2 secs @ f11

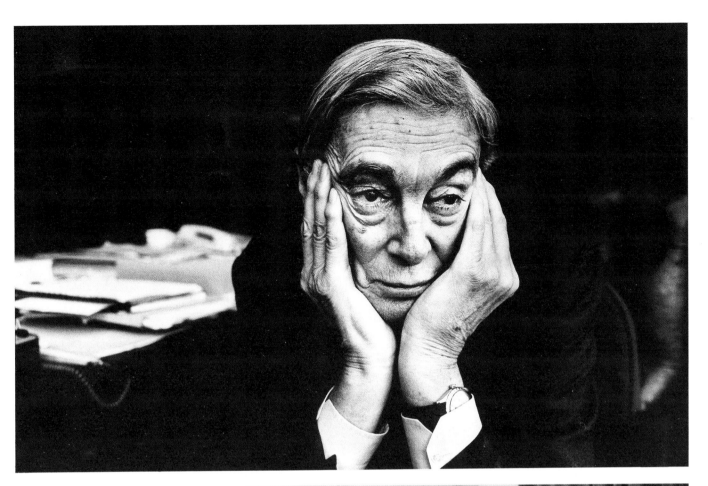

Above: **An unusual but very convincing use of hands in portraiture. The pose is well suited to the subject and emphasises the caring side of Lord Scarman's nature.**

Photograph Sally Soames

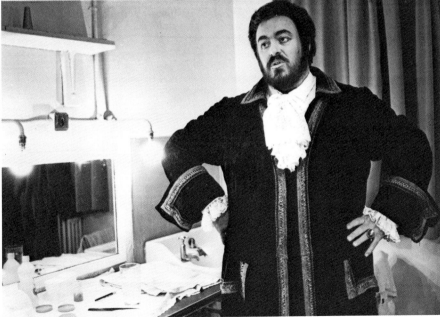

Right: **Luciano Pavarotti in his dressing room by available light.**

Kodak Tri-X, Nikon 35mm, 1/60th sec @ f2.8

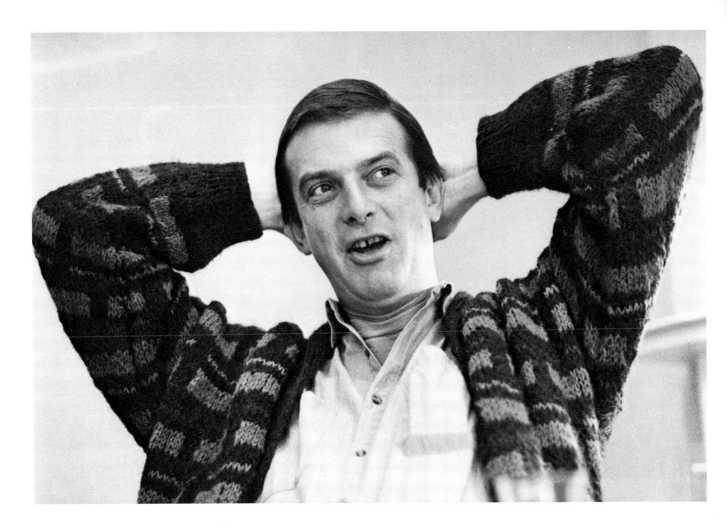

Film director Mike Newall. Using a
unipod is a versatile means of keeping
the camera ever ready for changing
expressions during a long interview.

Kodak Tri-X, Nikon 35mm, 1/125th sec @ f4

Facing page: **If you photograph someone
as lively and questioning as Germaine
Greer, it can be very difficult to
concentrate on the subject at hand. I did
manage to stem the flow of words for a
little while by asking her to face the
wall for a shot in profile.**

Kodak Tri-X, 6 x 7 Mamiya 110mm, 1/30th
sec @ f4

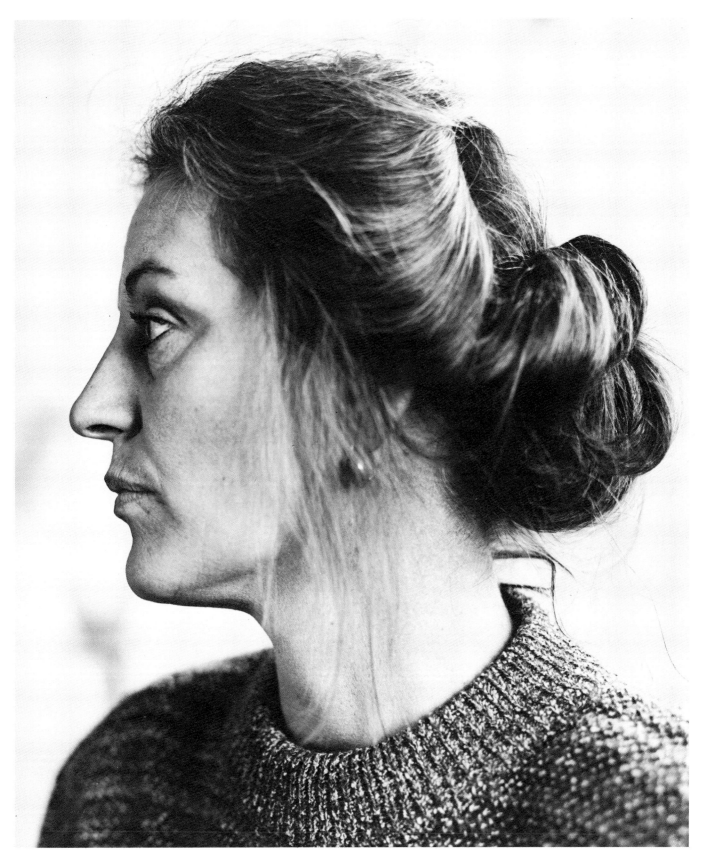

Lady Diana arrives at Heathrow. With a long enough lens you may get a worthwhile portrait even from something as mundane as the arrival handshake.

Kodak Tri-X, Nikon 300mm, 1/1000th sec @ f5.6

The Queen Mother at Windsor Castle for the Garter ceremony, taken without the benefit of a position reserved for the Press.

Kodachrome 64, Nikon 85mm, 1/250th sec @ f4

Left: **Trooping the Colour. An excellent occasion for photographing the Royals from the privileged position of the Press Stand.**
Below: **Eyes right for the march past the Queen.**

Kodak Tri-X, Nikon 600mm, 1/2000th sec @ f5.6

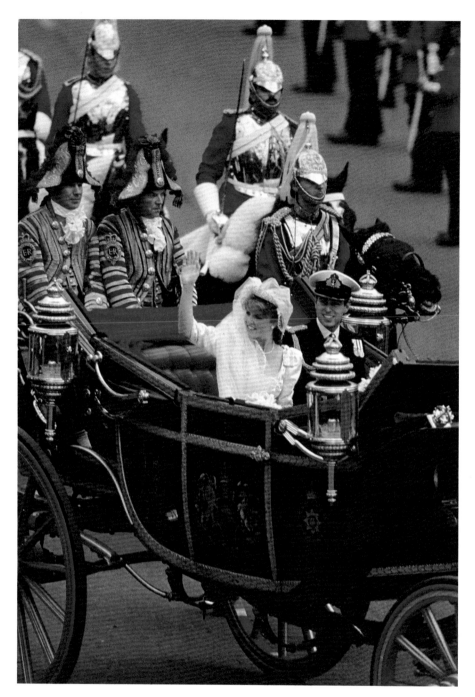

A royal wedding. The Duke and Duchess
of York in the Mall. One of those
occasions when every available long
lens will be rented out months before
the event.

Fujichrome 100, Nikon 400mm, 1/250th
@ f5.6

The Studio Portrait

Setting up a Studio

If you are just setting up as a portrait photographer, it is unlikely that you will be able to afford the price of a rented studio. The alternative is to convert one of the rooms in your house for this purpose. Ideally the studio should be 15 x 12 feet for head and shoulder portraits. If you were intending to do full-length figures, another three or four feet in depth would be necessary. If, in a 15-foot studio, you start shooting with wider than normal lenses in order to accommodate the whole figure, you will find that the edges of the background paper are continually coming into frame. Where possible you want your subject 4 or 5 feet in front of the background, in order to lose any shadows cast and to lessen the effect of subject lighting affecting the background.

To have a light or dark studio is another consideration. I myself would favour white walls and ceiling, so that you can easily use bounced light if required. For the low-key photograph you would tend to use narrow beam lights which will be unaffected by the wall surface. However photographers are divided on this point, some even favouring part dark and part light surfaces. If you get yourself a couple of large 4 x 6-foot reflector screens, the problem ceases to exist. Ideal for this are sheets of polystyrene. They are cheap and light and just need a simple home-made wooden stand to make them practicable. If you paint one side black, a whole range of lighting situations can be taken care of.

Rolls of background paper come in widths of 4 1/2 or 9 feet. For the basic head and shoulders portrait 4 1/2 feet is adequate. Expandable poles between wall and ceiling can act as background paper supports but in an old-fashioned high-ceiling house, you are better off with a pole supported between two light stands. You will need at least two different rolls of background paper, one black and one white. Cheaper than buying a whole range of coloured background papers is to buy a set of coloured gelatins. You cover a lamp with your chosen gelatin and can change the colour of the background in seconds. In order to minimise the extraneous subject light that will inevitably fall on your background, you will need to increase the distance between the subject and the roll of background paper.

Lighting Equipment

To be able to cover a variety of lighting situations, you will require at least three lights: one as your key light, one as your fill-in and the third as a background or special-effects light. For this purpose the third light should be a narrow beam or spotlight. The true spotlight is expensive but with flash equipment the honeycomb is an inexpensive and very effective alternative. You can vary the width of the beam of light according to the size of mesh on the honeycomb attachment. The honeycomb can also be used with halogen tungsten lights, although barn doors are the most widely used method of restricting the light spread by a tungsten lamp. These are black painted flaps which attach to the sides of the lamp holder.

Seating

This may seem straightforward but in fact it has considerable effect on the possible variations in pose. A comfortable armchair would be the least acceptable. A stool is good, in that the body can move freely in a circle. Lack of support for the arms is a drawback. I find a low-standing chest excellent for many situations. You can also bring arms and hands in close proximity to the face by asking your subject to sit on the floor and use the chest as a table to lean on. A similar pose will be achieved with a low-backed chair with no armrests. Get your subject to sit astride the chair and they will automatically lean their arms on the low backrest.

Camera Angle

Whether you know someone well or are photographing them for the first time, it is as well to spend a few minutes chatting before you start the photographic session. Apart from easing the situation, which to some people is as daunting as a visit to the dentist, this will give you an opportunity to study your subject's facial movements and characteristic gestures. You can now make a decision about the type of lighting you will wish to use. You can also decide on camera angle and which positive features you wish to accentuate and which negative features you will try to ameliorate. A large chin will look even larger from a low angle, whereas a small forehead can be made to appear bigger when taken slightly from above. The rules of perspective dictate that the relative size of an object depends on its proximity to the camera lens. If you draw an imaginary line down the centre of a face, you will notice slight differences to each half including the hair line. Bear this in mind when choosing the three-quarter face and profile. Try varying the angle of the head so that it creates a strong diagonal element in the picture. As a rule get your subject to sit at 45 degrees to the camera and then turn their head to face the lens. The head-on shot is too static and too square—in every sense. I tend to like my subject to look straight into the lens. A downwards or sideways look can add greatly to the mood of the photograph but too often, the look away from the camera carries with it a feeling of falseness. You sense the presence of the photographer directing his subject. Portraits of people looking heavenwards can be particularly grating.

The eyes are the focal point of a good portrait. Shadow from the eyebrows and eyelids gives depth and form to the eyes. Take care not to cast the eyes in shadow—something that may not be easy where your subject has deep-set eyes. One solution in this case is to raise the chin slightly but as with many solutions this may cause another problem elsewhere. A haughty, arrogant expression may be the consequence and to avoid this you will need to raise the

camera, so that now it is looking down on your subject.

Complexion

The bold, close-up head can make a strong, compelling photograph with the right face and, of course the right complexion. Skin texture and character lines look marvellous in close up but very often these may be the very things that your subject wishes you to suppress. In black and white, slight over-exposure will tend to wipe out smaller skin imperfections but this is not a method you can use with colour transparency film. (In this case no corrections can be made at the printing stage, therefore the exposure must be correct overall.) Some form of diffusion or soft focus is the best method of flattering your subject and minimising the effects of ageing. The High Street portrait photographer Brian Parry, as quoted in the previous chapter, uses a Softar soft focus filter for all his portraits. Special soft-focus lenses have been on the market since the end of the 19th century but other methods, which entail no extra expense, are also very effective. Most popular is the 15-denier black-nylon stocking placed over the lens during exposure. You can also spread a thin layer of petroleum jelly on a clear U.V. filter. This is a good method where you wish to have a sharp centre (keep the centre clear of jelly) and surroundings which become progressively more out of focus.

Lighting

In a previous chapter, I have discussed the conventional lighting set up—key light from the side and fill-in by the camera. To achieve the desired balance between the two, flash units with output control are very useful. A quick turn on the control will raise or lower the required output of light. The correct balance will be clearly visible with the use of modelling lights and can also be checked on the flash exposure meter. When you have mastered this technique, it is time to explore some of the more interesting lighting possibilities.

The fashion photographer John French pioneered high-key lighting in the fifties. Lord Snowdon was just getting into photography at this time and quickly became one of the most sought-after photographers in London. In his book *Sittings,* Snowdon pays tribute to John French whose work he much admires but feels has been underrated. Certainly he must have been an excellent teacher when you consider some of the photographers who learned their trade as assistants in his studio—David Bailey, Terence Donovan and Terence Duffy. In 1964 Snowdon photographed the actress Britt Eklund for the Atticus column of the *Sunday Times.* In those days pictures were wired to Manchester to be made up for the northern edition. The blockmakers were on the point of painting in the outline of the head, before it was pointed out to them that this was an effect intended by the photographer!

High-key lighting uses only reflected light and thereby eliminates any possible area of shadow. The feeling of cleanliness and purity with this lighting makes it ideal for photographing women with light hair and complexion. It aims to create a dream world but a very alluring one. To attain this effect, you need to surround your sitter with as many white reflective surfaces as possible. Bounce at least two lights from either side of the camera and use the third light on the background. If you have more lamps available, then so much the better. There is a variation to the high-key photograph where the overall effect of lightness is maintained but a definite dark outline to the face and body is visible. This effect is achieved with the use of large black reflectors to either side and slightly behind the figure. The lighting is large umbrella flash from the camera position and one light on the background.

For the photograph in profile, whether three-quarter or full profile, accentuate the outline of the profile with a spotlight (or honeycomb) from above and behind the subject, splashing pools of light onto the face. For your main light you just need a soft overall light, either bounced from an umbrella or, as in the example bounced from a large white polystyrene reflector 4 to 8 feet from the subject (one which creates a light softer than umbrella light). I also used a diffused honeycomb (added layers of tracing paper) to add life to the hair. To avoid flare, care must be taken that no light from the spots shines directly into the lens. A good lens hood is essential and make sure that the shadow created by the lens hood falls short of the rim of your lens.

Backlighting is always effective if a trifle theatrical. Again I used soft bounced light from the front, with a deep, narrow reflector on the lamp placed behind the subject's head. With smooth hair, this lighting produces a narrow rim of light around the head, whereas with looser hair, a spreading golden halo is the result. The backlight needs to be at least two stops brighter than the main light for the effect to be sufficiently pronounced. This should be no problem since the backlight is placed so much closer than the main light to your subject, in order to hide it from the camera's view.

The quality of the lighting gives a strong emotional impact to the photograph. Where high-key and soft lighting is synonymous with femininity, the low-key portrait gives a feeling of strength and gravity and for this reason has been traditionally used for male portraiture. The lighting also brings out character lines and skin textures which are such an interesting feature of a well-lived-in face. For this type of portrait, use a black background and a spotlight or honeycomb which gives a harsh directed light, leaving the shadow area quite black. A single light is all you need, though a second light on a section of the background will define the shape of the head if you so wish. This partial illumination of the background is called 'flagging' and you will need barn doors on your lamp holder to control it effectively.

Sometimes, and mostly for editorial purposes, one wants to recreate the sort of single, low-light source emanating from a fire, a television screen or even a candle. By firing the flash through a white transparent umbrella instead of bouncing the light out of it, you may very easily achieve the desired effect.

As you may have gathered from some of the lighting set-ups described in this chapter, often the very simplest lighting can be the most effective. You don't require a profusion of lights in portraiture—as with so much else, the simplest is very often the best. Use light to bring out character and create mood but don't overdo it so that you swamp the personality of your subject. It is also important that you build up your lighting step by step so that you are fully aware of the purpose of each light. Sometimes by adding yet another light, you may kill off the effect that you originally intended. Above all, you don't wish to end up with a portrait, which may have dazzling lighting effects but in which the subject may have become little more than an object.

I used reflected light in this portrait (see diagram) to give shadow-free light, which tends to look better with dark skin. A diffused spot added highlights to the hair. In order to vary the colour of the background I use coloured gels projected onto a white paper roll. It is cheaper and simpler than storing many rolls of different coloured paper.

Ektachrome 100, Mamiya 6 x 7, 180mm, Studio flash

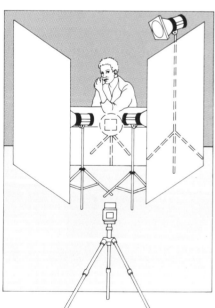

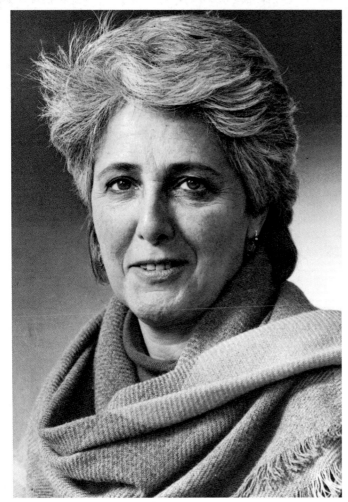

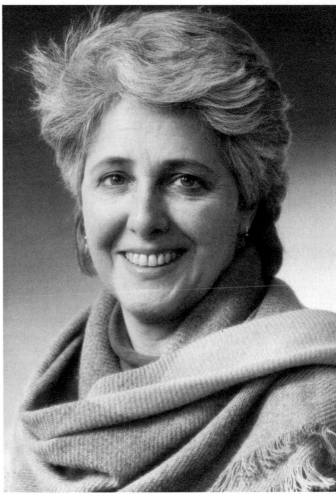

Above left and right: **Only the most perfect, youthful complexions can withstand the scrutiny of the modern multi-coated lens. If you wish to flatter your sitter you can use a soft-focus lens or, for far less outlay, a soft-focus filter. In this example I have used the cheapest method of all—a 15-denier black nylon stocking stretched over the lens during exposure.**
Left: normal. Right: diffused through 15 denier nylon.

Ilford HP4, Mamiya 6 x 7 180mm, Studio flash

Right: **The lighting for this portrait is basic and straight-forward, with the object of flattering the subject. It is sometimes referred to as 'classical' lighting and is the basis of the well-lit studio portrait. The key light (in this case flash bounced from an umbrella) is placed at 45° to the sitter and about two feet above head height. This accentuates the cheekbones. Shadow from the eyebrows gives good modelling and depth to the eyes.**
 The shadows created by the key light are softened by a weaker second light placed on the same side as the key light and as close to the camera position as is convenient. Watch that no light from your fill-in is directed onto the camera lens. A lens hood is essential. To vary the tone of the background and to outline the shape of the head, I directed a light onto part of the background. The output from this third light was controlled with 'barn doors' fitted to the lamp holder.

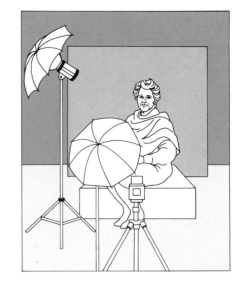

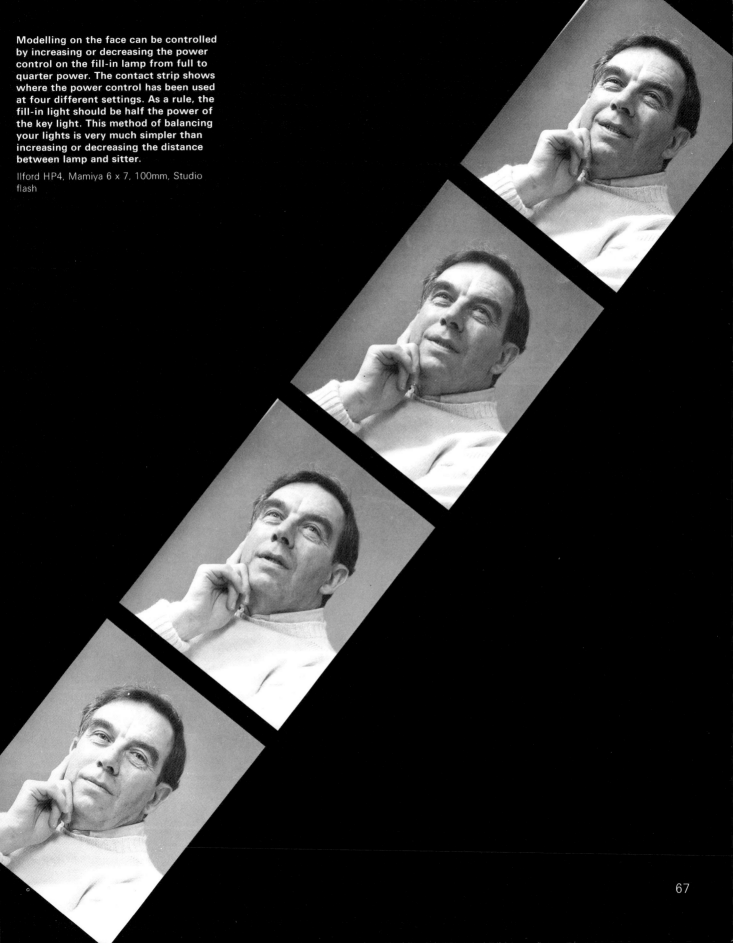

Modelling on the face can be controlled by increasing or decreasing the power control on the fill-in lamp from full to quarter power. The contact strip shows where the power control has been used at four different settings. As a rule, the fill-in light should be half the power of the key light. This method of balancing your lights is very much simpler than increasing or decreasing the distance between lamp and sitter.

Ilford HP4, Mamiya 6 x 7, 100mm, Studio flash

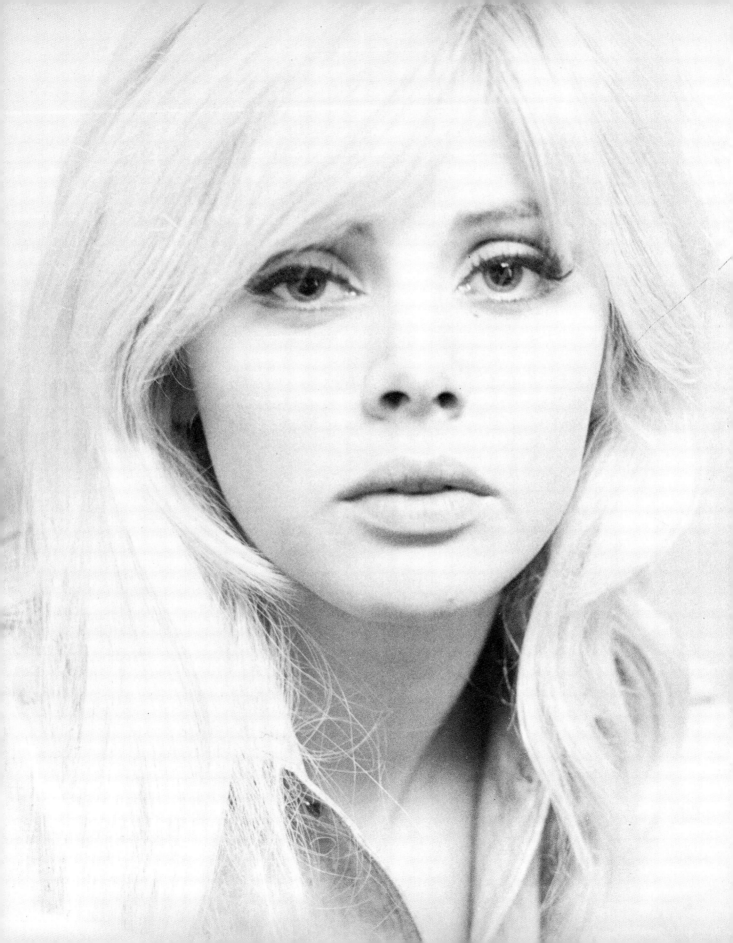

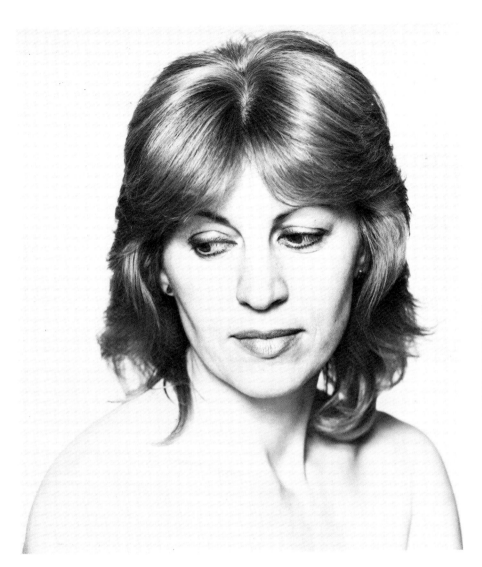

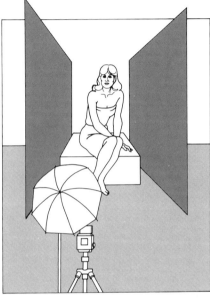

Above: **A picture which retains the light, airy effect of the high-key portrait but still outlines the contours of the face and body by using black reflector boards in conjunction with a soft frontal lighting.**

Ilford HP4, Mamiya 6 x 7, 180mm, Studio flash

Above: **One umbrella flash from the camera position was the only lighting for this portrait. The dark outline to the face and body were enhanced by using large black reflector boards to either side. You can acutally watch their effectiveness increase as you get them into the right position.**

Facing page: **This beautiful high-key portrait of Britt Ekland lays great emphasis on the eyes by almost whitewashing everything else. When it was used in the *Sunday Times* in the 60s and wired to Manchester for the northern edition, the blockmakers had to be restrained from retouching what they had assumed was a badly wired print!**

Photograph Snowdon

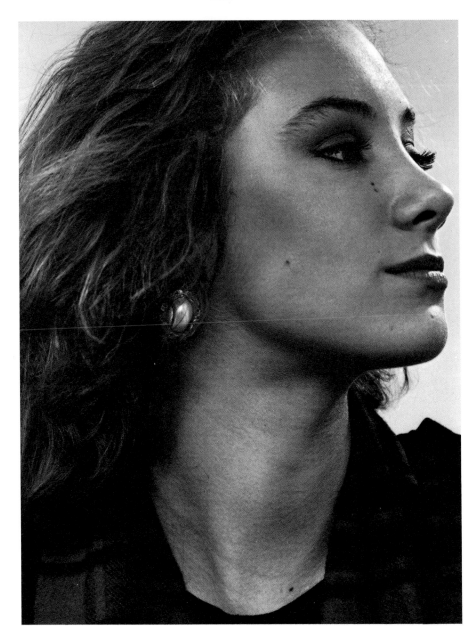

The three-quarters profile can be transformed by the use of a spotlight (or honeycomb, as here) to highlight the contours, spilling over onto chin and forehead. The main lighting is soft, reflected, with minimum shadow but dull enough to allow the highlighting to register. A diffused spotlight has been used to brighten the hair.

Ilford HP4, Mamiya 6 x 7, 180mm, Studio flash

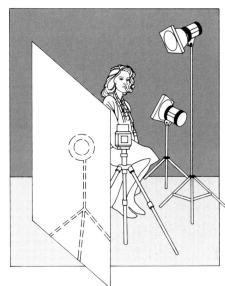

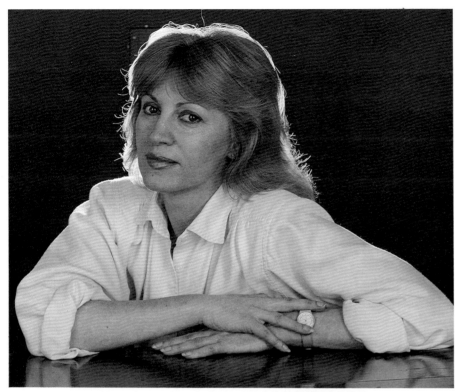

A spotlight behind the subject's head will give a very dramatic portrait. It is a romantic type of lighting generally more effective with women than with men. The effect can be very different according to the subject's hair, as I demonstrate in these two examples. Straight hair produces a fine delicate contour whereas curly or fluffy hair produces a wonderful blazing halo. Light the face with soft, reflected light. The darker the face, the more dramatic the halo effect. Try using coloured gels over the backlight to add another dimension. To measure the exposure, ignore the brilliant back light and just take a reading from the face.

Ilford HP4, Mamiya 6 x 7, 180mm, Studio flash

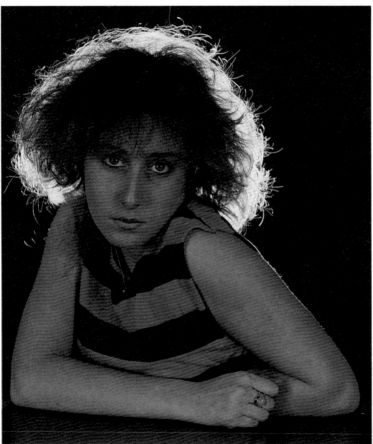

Left and below: **Light bounced from reflector boards on either side of the sitter produce soft, even lighting. The halo of light is created by placing a lamp close to the back of the head; make sure that no direct light shines into the camera lens.**

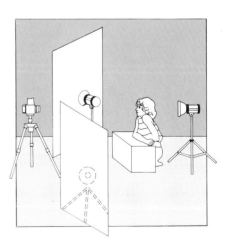

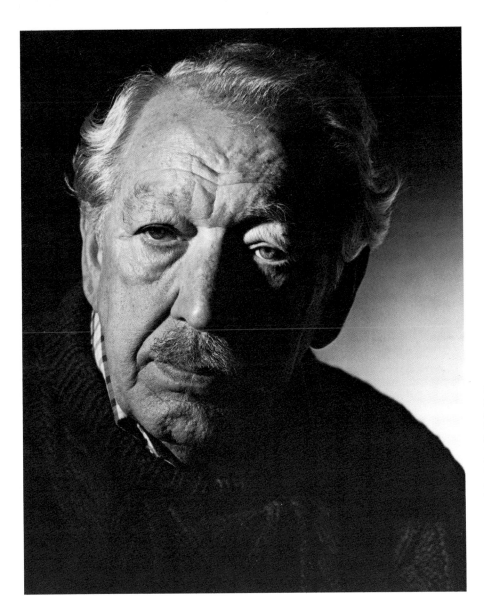

Left: **Simple lighting is very often the most effective. The face has been lit by a single spotlight, carefully placed so that the eye shines through the shadow side of the face. The background is 'flagged'—that is, the light side of the face stands out from the unlit background whilst the dark side contrasts with the light background. This contrasty lighting which brings out skin texture so well, is especially suited to portraits of men.**

Ilford HP4, Mamiya 6 x 7, 180mm, Studio flash

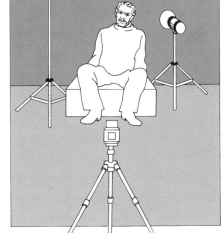

Diagram 6
Right: **A honeycomb spot at 75° and twelve inches above the sitter lights the face. The background is lit by a lamp with 'barndoors' attached to control the spread.**

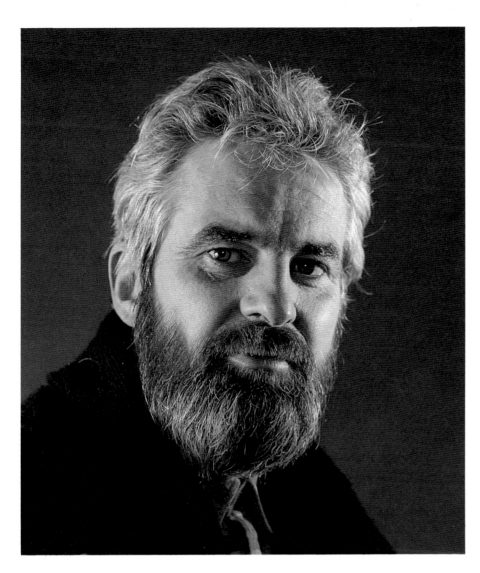

Left: **Strong side-lighting that brings out lines and contours is effective with men with rugged weather-beaten faces. The effect here has been muted to some degree by a weak fill-in from the camera position.**

Ektachrome 100, Mamiya 6 x 7, 180mm, Studio flash

Right: **Two honeycomb spotlights are placed slightly to the rear and above the sitter. They are three times more powerful than the fill-in umbrella flash.**

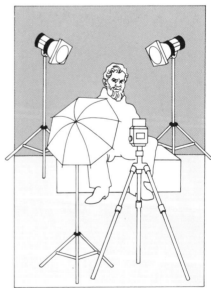

73

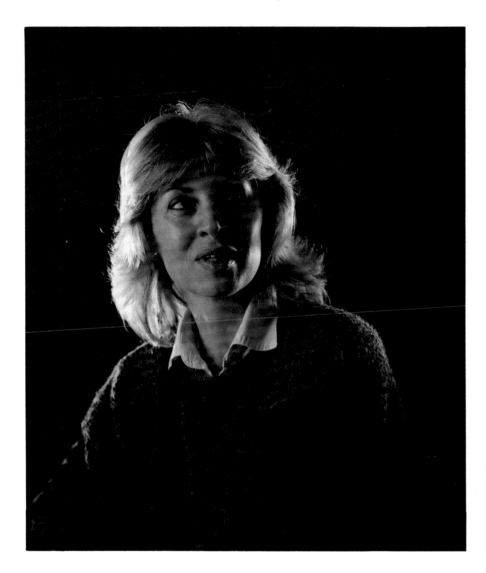

Left: **Here the side-lighting gives a more romantic effect by being placed more to the rear, thus highlighting the hair and cheek. The key light is a softer reflected light from the side.**

Ektachrome 100, Mamiya 6 x 7, 180mm, Studio flash

Right: **Honeycomb spotlights bring out the texture and colour of the hair. fill-in is from light bounced from a reflector board. The effect has been softened by using gauze over all the lamp holders.**

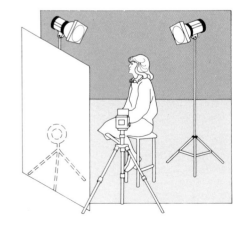

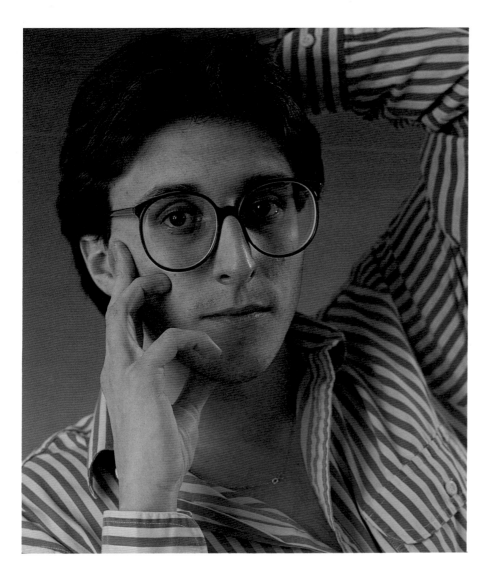

Left and below: **Spectacles can present problems with unwanted reflections which can best be avoided by using only side lighting on your subject (see diagram).**

Ektachrome 100, Mamiya 6 x 7, 180mm, Studio flash

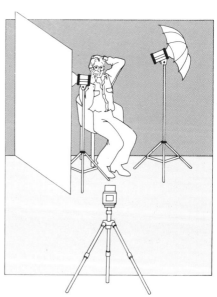

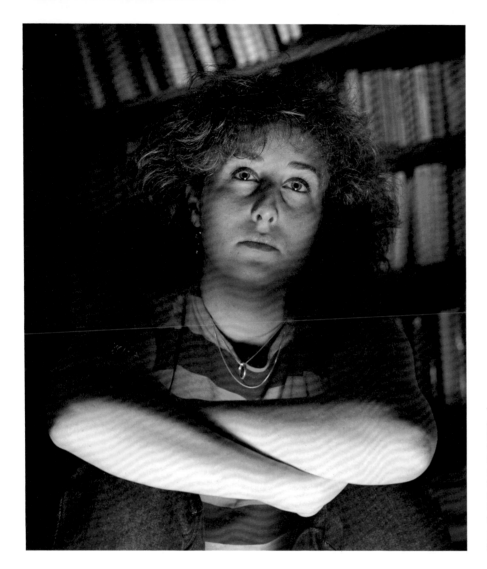

To create the sort of lighting you would get from sitting by a glowing fire or in front of the TV screen, reverse the white umbrella and shoot through the fabric from a low position. This will produce a soft yet more directional light than reflecting the light off the umbrella in the usual way. A second light has been used to throw light on the bookcase in the background.

Ilford HP4, Mamiya 6 x 7, 110mm, Studio flash

Colour

The *National Geographic* was the first magazine to use colour extensively. In those pioneering days you made sure everyone appreciated the new technology by having a girl dressed in red or yellow, or possibly both together, in the bottom left-hand corner of every picture.

We as viewers have become a little more sophisticated since then. The colour no longer needs to shout from the page—it can be muted and subtle as often as strident and boisterous. Above all it should contribute to the emotion of the picture and our knowledge of the facts. If someone has beautiful red hair, then there is no way that a black and white photograph can convey that information. Neverthelesss, to make it appear redder by putting it next to green is like having ice cream with cream on top.

Some colours may complement each other, where others may act in discord. We all, as individuals, have certain preferences. Blue and green are meant to be discordant but I find they vibrate in an exciting, pleasing way. The psychology of colour is yet to be fully understood. Market research has shown that the sales of a book may increase when there is a large amount of yellow on the dust jacket. The explanations are numerous—yellow is a warming, pleasant colour associated with the sun—and never totally convincing. Certain colours do have associations derived from their disposition in nature. Red is an exciting, dramatic colour. Its associations are with blood and fire and sunset, the time for romance. (Perhaps the latter explains the association between red and the erotic, the red-light district'.) Yellow and orange have all the warm associations of sunshine, marigolds, a ripe field of wheat. Blue is more distant, cool—the sky forms a backdrop to all our outdoor views, and the cool of water

is associated with blue. Green is more neutral. It has the energy connected with growth and the coolness connected with foliage and shade. The many shades of colouring in between have varying connotations of warm and cool, based on these perceived associations in nature. If we wish to create a restful picture, we can use either the warm colours or the cool colours together in harmony. For a more lively, dynamic result, the different extremes of colour should be used together but without becoming discordant.

Colour Temperature

Our perception of colour is dependent on the quality of light falling on it. White light is a combination of all the colours of the spectrum and if you add or subtract some of the colours of the transmitted light, so the reflected light (perceived as the colour of the object) will change. Our brain tends to make adjustments so that we perceive colour as we know it to be. Film cannot do this—it records colour scientifically. If you were to photograph a post box at hourly intervals from dawn till dusk, you would see the change in colour from almost blue pre-sunrise, to the bright red pillar box we know it to be, at noon.

Colour temperature is measured in Kelvins. Film manufacturers have balanced their films for the two most generally used light sources—daylight at 5500K and tungsten at 3200K. The table printed below gives a range of colour temperatures and their source. If we use daylight film with tungsten light, the results will have an overall yellow cast. Tungsten-balanced film used in daylight has a strong blue cast. It is not always necessary for the film to be exactly colour balanced to the light source. As a general guide, the eye accepts a warmer rendition more readily than a cooler one. Thus the warm tones

of daylight film shot at sunset are far more acceptable than the overly blue tones experienced in overcast conditions and especially at high altitudes. Tungsten film takes on an unacceptable blue cast when used with photoflood lamps at 3400K, but is quite acceptable with low-level bulbs and even the red glow of candlelight at 1500K.

COLOUR TEMPERATURE SCALE IN DEGREES KELVIN	
High Altitude Skylight	— 20,000K
Overcast Sky	— 10,000K
Noon Sun	— 5,500K
Electronic Flash	— 5,500K
Fluorescent Daylight Tubes	— 4,800K
Sunrise or Sunset	— 4,200K
Fluorescent White Tubes	— 3,700K
Photoflood	— 3,400K
Tungsten	— 3,200K
Household Bulbs	— 3,000K
	– 2,650K
Candlelight	— 1,500K

Colour-Correction Filters

For completely accurate colour rendition, colour compensating (CC) filters would have to be used either over the lens or over the light source, to reduce or increase colour temperature to equal that of the film. There are colour compensating meters which, as well as indicating the colour temperature, show the necessary colour compensating filter to use.

One light source remains difficult to correct and that is the neon tube. It leaves a very unattractive mauve or green colour cast with both daylight and tungsten film. There are several different types of neon and they vary in colour temperature from 3700K to 4800K. Colour temperature may also vary with length of use. A colour temperature

meter is especially useful in these circumstances. For those of us who do not possess this expensive item, tests with varying strengths of Magenta and Cyan gelatin filters are necessary. There are two glass filters on the market. FL-Day is for use with daylight film and daylight-type fluorescent light. FL-W is for use with tungsten film and warm white-type fluorescent light. These filters are suitable for correcting the two most widely used type of neon.

Skin Tones

The totally accurate rendition of colour is not really the concern of the portrait photographer but, for the reproduction of paintings for instance, it can be very critical. Of greater concern to the portrait photographer is the rendition of skin tones. The appeal of a portrait can depend to a large extent on this factor and for this purpose a slight lowering of the colour temperature is necessary. I find the colour compensating gelatin filters made by Kodak excellent for this. These are square sheets of gelatin and come in varying sizes. You can either cut them out to fit your particular lens or else buy a gelatin filter holder. Make sure this has a lens hood attachment, as the filter holder will obstruct the use of the normal lens hood. With flash pictures a CC10 Yellow gives just the right amount of warming to the flesh tones. If you want to give someone an attractive tan, then use a gold umbrella or reflectors covered in gold foil. For daylight pictures, the skylight filter will correct any excess of blue in overcast conditions but to effectively warm the flesh tones you need one of the 81 series of colour warming (temperature decrease) filters.

There are also filters for converting tungsten film to daylight and vice versa. This does however imply a loss of film speed and it is always better to use the film as designated, for the best colour rendition.

Reversal and Negative Film

Unlike monochrome, where it is automatically assumed that you will be using negative material, colour is clearly divided into negative film and reversal film. If publication is intended then you will be required to submit transparencies. With negative material the second stage (the making of the print) allows one to compensate for any small errors in exposure and colour control. With transparency material you do not have this possibility and the onus on getting it right first time is that much greater. But do remember to err on the side of under, rather than over-exposure. With over-exposure the colours will be washed out and nothing will bring back what's not there. With under-exposure, the colours will be heavy but definitely viewable if looked at through a stronger light source. If the colour is there, a good printer will be able to bring it out when making the block.

Because the possibilities of correcting the original are so slight with reversal film, many photographers like to bracket their exposures by half a stop. This means using three frames for each shot and is not really applicable in much of portraiture, where spontaneous expression is such an important ingredient. In difficult lighting conditions however and where you are using a more stylised pose, it is certainly worth using a bit more film in order to make sure of a first-class result.

The machine-processed prints obtainable from colour negative material can be quite acceptable from a well-balanced negative. Should you have a dark background or extremely contrasty lighting, the machine will average out the exposure resulting in a ghostly white face and complete lack of detail in the highlights. In this case you would have to select one of the more expensive professional colour laboratories where colour printing is done by hand.

Colour Saturation

Three things affect the intensity of colour as perceived by the viewer:

1. Reflected Light: A red object is red because it absorbs blue and green and reflects red. If the object has a highly reflective surface then a certain amount of the blue and green rays will be reflected with the red, thus diluting its colour saturation. Bounced light rather than direct light will lessen the amount of reflection and increase intensity. If you avoid shadows, the area of pure colour will be the greater.

2. Colour Contrasts: Black is an excellent background to use for intensifying colour effect. White will tend to dilute strength of colour. Place small areas of intense colour in a large area of muted colour.

3. Exposure and filtration: Colour will deepen and strengthen as you reduce exposure but inevitably your subject's face will also become darker. A blue sky may be given fuller saturation without darkening the subject's face by use of a polaroid filter. In this a polaroid filter can be said to have the same function for colour film as a yellow filter has with monochrome. The polaroid filter also cuts down the light reflected from shiny surfaces such as metal and glass which increases colour saturation. Exposure times are increased by one stop.

The points outlined in this chapter will help you in your use of colour but they will not help in the decision of when to use colour and when to use black and white. I think of colour as documentary and informative; as a matter of likeness it tells you more about the subject. As evocative of place and time and weather conditions, it is undoubtedly superior to monochrome. Emotionally as we have discussed, colour can create a strong response in the viewer. Colour associations, be they conscious or subconscious, are extensive and varied. Yet when I look at the portraits of some of the photographers whose work I most admire—Lord Snowdon, Henri Cartier Bresson, Bill Brandt, Irving Penn, Richard Avedon and Arnold Newman—they are all in black and white. Perhaps the surface information and even the definite atmosphere and emotion created by colour can come between the viewer and the essential truth of a great portrait.

Shocking colour—using colour to compel the viewer's attention. The outlandish skin tones were obtained by using coloured gels over the spotlights.

Ektachrome 100, Mamiya 6 x 7, 110mm, Studio flash

Muted colour—using colour to create mood and emotion. The girl is friendly but not beckoning. It is the attachment between animal and human that comes across through the pose, complemented by the blending of colours. The harmony in the pose is echoed by the harmony in colour.

Kodachrome 64, Nikon 50mm, 1/125th sec @ f4

Scintillating colour—I came across this
Tuareg tribesman in northern Mali and
fortunately he was willing to be
photographed, as his sense of colour
was irresistible.

Kodachrome 64, Nikon 50mm, 1/500th sec
@ f5.6

Pre-sunrise, colour temperature is at the high end of the scale particularly at high altitude with its preponderance of UV rays. Without the correct colour-balancing filter your picture will have a strong blue colour cast as in the above example.

Fuji 400, Nikon 35mm, 1/30th sec @ f5.6

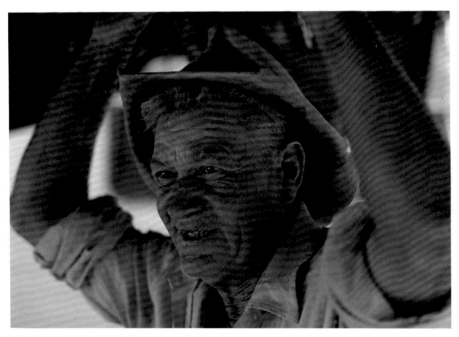

The warm red rays of sunset give flesh tones a bucolic glow, not inappropriate in this picture.

Kodachrome 64, Nikon 85mm, 1/125th sec @ f4

1.

2.

3.

4.

5.

The pleasant rendering of skin tones is a constant challenge in colour photography. You can either warm the light source or filter the light reaching the film. The above examples are:

1. no filter
2. 81A filter
3. CC10Y Gelatin filter
4. Gold umbrella as key light, white umbrella as fill-in
5. Gold umbrella as sole light source

Lighting is bounced from two large reflector boards with a further light on the background

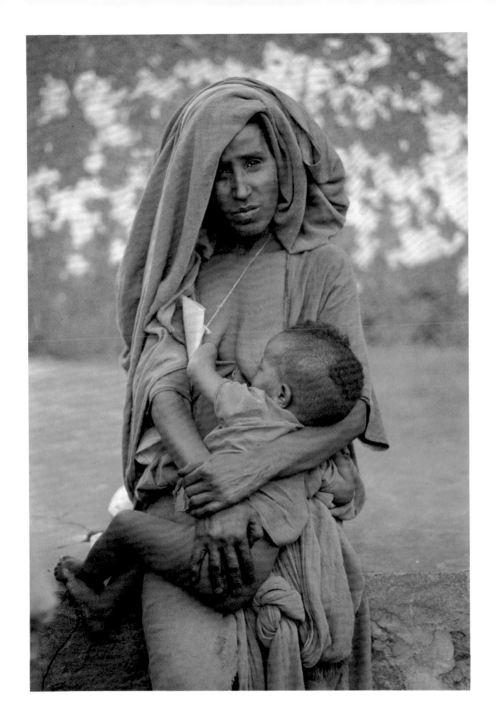

Ethiopian mother and child at Alomata refugee camp. The matching material worn by mother and child, no doubt brought about through necessity not choice, adds to the feeling of unity.

Kodachrome 64, Nikon 85mm, 1/250th sec @ f4

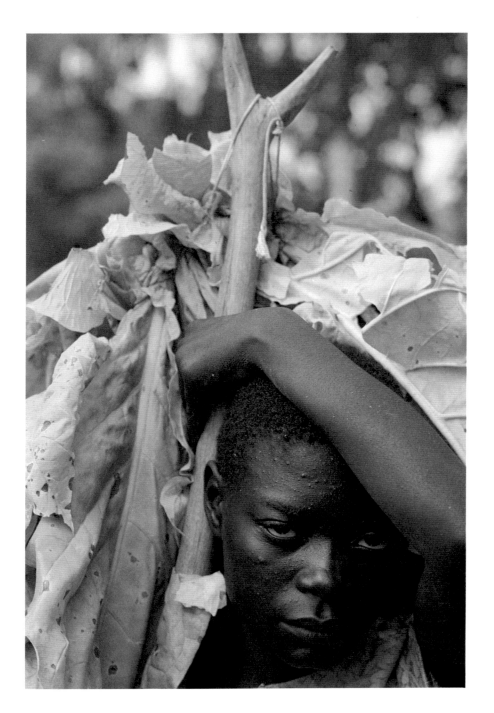

Tobacco farm worker in Zimbabwe.
There is a quietness about the colour in
this picture which, though attractive,
never conflicts with the overall sense of
burden.

Kodachrome 64, Nikon 85mm, 1/250th sec
@ f5.6

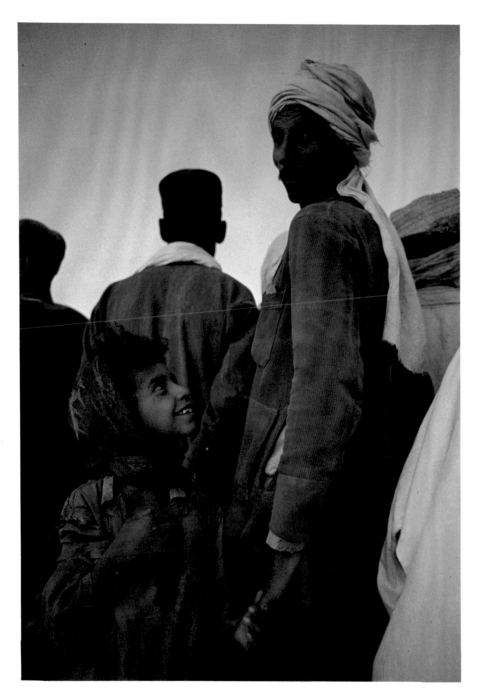

For about half an hour just after sunset
the light can be quite magical: soft and
warm and ideal for portraiture.

Ektachrome 200, Leica 35mm, 1/60th sec
@ f4

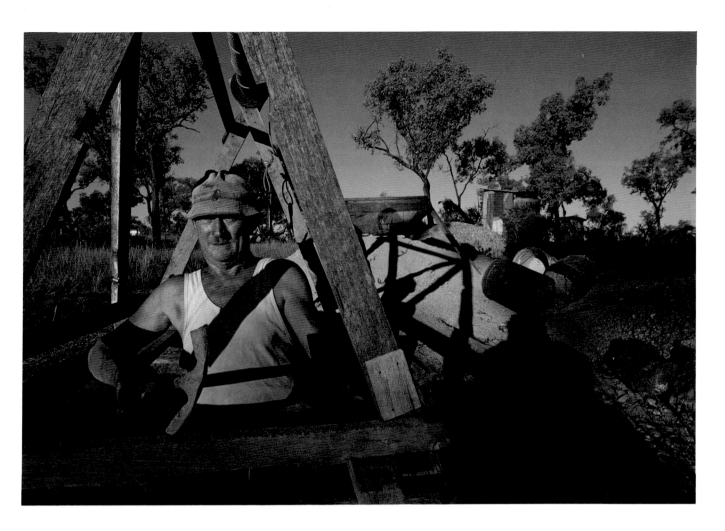

In this portrait of a miner in the
Australian outback, the intense blue of
the sky has been emphasised by use of a
polaroid filter.

Kodachrome 64, Nikon 24mm, 1/250th sec
@ f5.6

Composition and Effect

It has been said that a good photographer can take something as trivial as a box of matches and make a compelling photograph out of it. Edward Steichen, one of the 'greats' of American photography (towards the end of his life he organised the exhibition 'The Family of Man' that swept the world), spent a year photographing a cup and saucer as his apprenticeship into the art of photography.

Take a matchbox, place it centre frame on a neutral background, bang a light on it and you have a presentation suitable for a mail-order catalogue. Now use your imagination, change the background, add light and shade and above all move the matchbox from the centre of the frame and vary the composition. You will have created a real photograph.

Balance and Flow

The information, the message, which a photograph conveys to the brain, comes through the eye and it is the eye in the first instance that our photograph must appeal to. Three elements in a photograph all hang closely together and all need to be given equal consideration—subject, lighting and compositon. There are rules governing composition which refer to balance and harmony in the distribution of shapes, movement along diagonal lines which the eye easily follows and a pleasing sense of proportion, based on the division of thirds. By all means bear these elements in mind when composing your picture, as long as you don't adhere to them slavishly. The rules all direct you to a harmonious, pleasing, uniform approach to composition when in fact, you may want the opposite—discord and the impact of surprise. What you almost certainly do not want is chaos and indecision.

To a varying degree, everyone has an innate sense of composition, particularly where it affects the balance in a picture. We feel almost physically uncomfortable when there is an absence of balance. Balance in terms of weight is a perfectly straightforward concept. Try to think of visual balance in a similar way. If you place your subject in the centre of the frame, the result is static. Now place the subject to one side—you have imbalance and a feeling of one-sided top heaviness. It is by introducing another shape, colour or design in relation to your subject that your sense of balance becomes satisfied. More than that, you have created a flowing movement in the picture. The eye should move easily around the picture and it does this most naturally where there is a geometrical shape that unites the various elements. Diagonal lines flow easily and at the same time create a dynamic interplay between the different elements in a picture.

Relating to the Environment

Your first choice when approaching your subject must be whether to shoot in a vertical or horizontal format. In this chapter I am thinking very much about the environmental portrait and the relationship between the subject and his surroundings. Whether this is to be a room, buildings or a landscape will very largely determine the format you choose. You want the subject to stand out from the surroundings and at the same time, the visual link between subject and surroundings must be emphasised. In the environmental portrait, the surroundings comment on the subject—there needs to be a creative tension between the two. This is a crucial element of the composition. The eye needs to be drawn from the subject to the surroundings and back again. Converging lines, as in the pictures of the black man and of the young conductor, do this very successfully. In the picture of the ageing painter, it is the strong diagonal link between the main objects that draws the eye. It is one thing to visualise these pictorial elements and another to compose them to satisfaction in the viewfinder. You must be prepared to adjust your viewpoint and to change camera lens accordingly. Try all the options and get in as close as you dare without distorting the features.

Defining Space

Think about the edge of your picture frame. I compare it to the way that a footballer controls the ball along the touch line and keeps it in play. In a similar way, the shapes that might be lost or overlooked in the centre of a picture take on a greater significance when they come up against that straight line, the edge of the frame. Creative tension between various elements in the picture will also be increased when there is this element of stretching to the very boundaries of your picture. But don't neglect another type of image that needs serenity and space around it. This is usually a head-on, centrally-placed image, where the attention to detail and tonal values are paramount. Another way of concentrating the eyes' attention on the subject is to frame your sitter by some object, such as out-of-focus flowers or leaves. The sharpness of the subject will appear that much greater when it is contrasted with the blurred surroundings. In this way the foreground may be transformed visually into the background.

The Dual Portrait

Composition becomes a truly crucial element in the dual portrait. The interpretation of character has to take second place to the relationship of the two people. If they are intimate, as husband and wife, then close contact will be easy

and natural to establish. With people not closely related, the demands of composition will very likely still require proximity, while a feeling of separateness has to be maintained. I find myself knowing exactly where I want my subjects' faces to be placed within the picture frame and yet bodies and especially shoulders, being what they are, make this physically impossible. The distance between the two heads may look quite natural and yet in the finished photograph there seem to be acres of empty space between them. You will have to ask your subjects to get far closer together than seems natural. Placing them back to back and then turning their heads to face the camera is one way of doing this. Another solution is placing an object between the two heads, such as the tree in this example, which will hide the awkwardness of their bodies. Take care when lighting the dual portrait, that no shadow from the face in the foreground, falls on the face behind it. Use either soft lighting, or else a separate light on each of the faces.

The Group Portrait

This is a very challenging area of photography, with technical problems in lighting and depth of focus and organisational problems in the need to direct large groups of people. The lighting will be very much easier if you can do the group shot out of doors. Look for a suitable location where you can easily vary people's height, as on a balustraded staircase. The only other way of differentiating between heads in a large group and filling the picture frame is for the photographer to shoot from a raised position, with everyone looking up into the camera. It is often difficult for the photographer to make sure that each person is in full view of the camera. I always point out that everyone should make sure they have a clear view of the lens—in which case the lens will have a clear view of them. It is also important that everyone in the group is looking in the same direction. A picture can be ruined by people looking in different directions. You need to be in complete control of the group and don't let them be distracted by other people present.

If you are doing a group in the studio, the best lighting is one light either side of the group and a central light bounced from a large reflector. In confined space, the side lights may very well have to be too close to the group, in which case the figures on the perimeter of the picture will be overexposed. You may be forced to settle for flat frontal lighting as the only means of obtaining even illumination.

With smaller groups of say, half a dozen people, the skill lies in arranging the heads at different levels to fill the picture frame. Even very small variations can make a world of difference and I find a supply of telephone books for people to stand on ideal for varying relative heights. Try arranging them to make strong geometric shapes but avoid the straight lines that make the team photograph as monotonous as a typewriter keyboard. Vary the size of heads to a certain extent, by having someone closer to camera. The difficulty here is depth of focus. You will need to stop well down, to f16 or even f22. With flash, depending on the power of your system, this may not be possible and here other forms of lighting, be it daylight or tungsten, are advantageous. You just need to increase the length of exposure.

Creating Movement

If you want to get a sense of movement into a portrait of someone in action, try panning the camera. Cycling is ideal for this type of shot. The effect of panning, which is to leave the subject sharp and blur the background, depends on the speed of the cyclist and the shutter speed. I find 1/60th about right for someone travelling at 15mph but a bit of trial and error is inevitable. Turn and follow the subject through the viewfinder as they pass you from left to right and fire the shutter smoothly when they are immediately opposite. Using a tripod with ball and socket head can be helpful, particularly when you wish to create a more pronounced effect and therefore select a slower shutter speed. Ernst Haas was famous for his blurred colour photographs using the panning technique. He covered many forms of action and created unique images, full of swirling colour and movement. The joy of this technique is the surprise in store for the photographer when he is successful, because the effects can never be accurately predicted.

The Zoom Effect

A similar effect of blurred movement can be obtained when the subject is not moving at all. You do this by actually zooming the lens during a slow exposure time of 1/8th of a second, with the camera on a sturdy tripod. In brightly lit conditions, this means using a slow film or neutral density filter. The centre of the picture is the only part that will remain sharp so place your subject dead centre and focus on the eyes. Select the wide end of the lens range and during exposure zoom-in as quickly as you can, so that the whole range of the lens' varying focal lengths are encompassed in the 1/8th of a second. When successful, this creates a marvellous feeling of movement in the landscape. Make sure you have a suitable background of light and shade and irregular shapes such as a well lit grove of trees.

Blurred Flash

Another way of creating movement is with the use of blurred flash. Again using a slow shutter speed, let the subject move quite vigorously during exposure. The flash will create a sharp image and the subsequent movement will register as a ghostly blur. For the blur to be at all apparent, you need to do this against a dark background.

The Action Portrait

We have looked at ways of creating the feeling of action and fast movement in a portrait. What about freezing the action itself? The face captured at peak effort can make a really stunning portrait but the skills required are considerable. Every year sees the growth, in quantity and quality, of action photographs. The sports photographer is a bit like the sports athlete, forever making new records and breaking the old. I think they are getting younger too! To a certain degree, this success must lie in the improved equipment coming onto the market. Without the new breed of ED (the type of glass used in these lenses) long focal length lenses and camera motor drives that can take up to six frames a second, these pictures would not be possible. At the same time the skill required in being ready and focused for the peak moment of action comes only with fast reflexes, a real understanding of the sport being covered in order to anticipate the action, and a lot of experience. Until the new breed of fast ED lenses became available, the sports photographers' favourite was the pistol-grip Novoflex with its

unique follow-focus action. It is still a very good lens for sports photography and much cheaper than the ED-type lenses which, because of their weight, are mostly used with a unipod as support.

Action by Tungsten Light

Ballet is another activity where the demands of action photography are paramount. If flash were possible or desirable, stopping the action would present no difficulties. However the lighting is an integral part of the theatrical performance and you could not possibly light a whole stage with flash to compare with the effects of carefully-arranged stage lighting. Apart from this, stage managements discourage the use of flash which would upset the performers, so once again it is the fast lenses with film pushed to its limits that will solve the problem. Whenever conditions allow, you will want to shoot at no less than 1/250th of a second. This inevitably means that the lens must be set at full aperture and exact focusing becomes crucial.

Where you have to use an even slower shutter speed, remember that action coming towards the camera can be frozen at a slower shutter speed than moving across it; there is also a moment of relative stillness when the dancer reaches the peak of his movement and it is these moments that you must try and catch if you are trying for a sharp image. But don't neglect the expressive blur that creates the sense of movement particularly if you are photographing in colour. As with sporting events, the motor drive supported on a unipod is a valuable tool for getting the right image.

Theatre and opera also offer plenty of scope for the action portrait. The fluctuating light which is often confined to small areas of the stage makes correct exposure a continual problem. With experience you should be able to judge relative light values fairly accurately. To be certain of your exposures you need a spot meter or metering through a telephoto lens, but you must have a battery-illuminated read-out in order to see the reading in a darkened auditorium. A pocket torch is an invaluable accessory when working in the theatre or opera. Modern opera performances have a tendency to be dark and underlit. The action however, is slower than theatre and ballet and you don't need to worry that you will miss the action by using a tripod, which really is an essential item. Exposures as low as 1/30th or even 1/15th of a second are quite common.

Pictures taken during rehearsal time can also be very rewarding. The lighting is very often appalling and the background disturbing, but the degree of concentration and involvement by the performers presents an ideal situation for the patient and observant photographer. Once you have been accepted as someone who works quietly and unobtrusively you are in the privileged position of being present during the exciting and creative period that ends in the stage performance.

Often the lighting is so poor that it may be necessary to rate your ASA 400 film at ASA 1600. That means a long development time and resultant graininess but at this raw stage in the production that may well add to the atmosphere.

To return to the opening theme of this chapter, it is worth mentioning the value that can come from studying the work of others. Don't limit your attention to photographs. There is always a certain cross-fertilisation between the various graphic arts. The painter inspires the photographer and vice versa. Your own sense of composition and design will benefit greatly by looking at paintings, posters and illustrations as well as photographs. Try to evaluate what are the compelling elements that make one image so much more powerful than another.

Left: **Author Margaret Forster photographed on Hampstead Heath. I wanted to retain the feeling of space without any recognisable distractions. By using a telephoto lens the background may be transformed into gentle tones of grey.**

Kodak Tri-X, Nikon 300mm, 1/1000th sec @ f5.6

George Benjamin was rehearsing for a concert to be held in this church. The back-lit flagstones and strong converging verticals immediately suggested themselves as a striking composition. Luckily the composer-conductor was young enough not to look totally out of place studying his score on the ground.

Kodak Tri-X, Nikon 35mm, 1 sec @ f16, fill-in flash

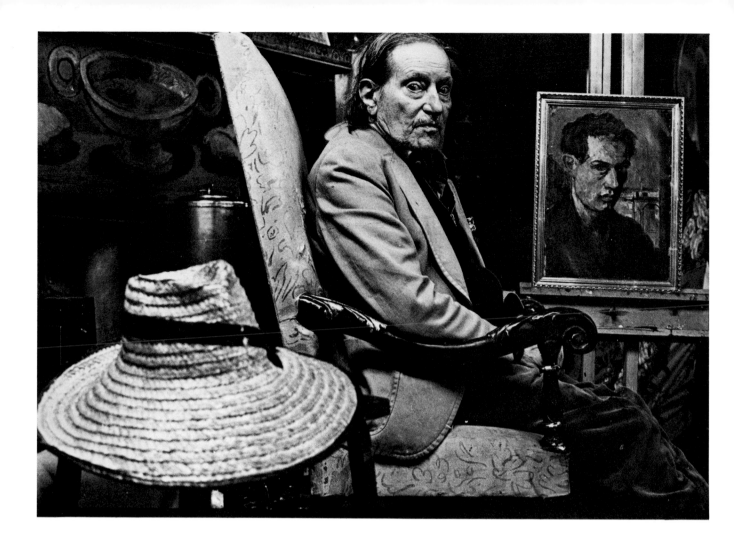

Painter Duncan Grant posed next to a
youthful self-portrait. I asked him to
take off the straw hat he always liked to
wear, to strengthen the comparison
between the artist and his painting. The
strong diagonal element in the
composition was brought about by
including the hat in the picture.

Kodak Tri-X, Nikon 35mm, 1/8th sec
@ f8

The contours of the profile are
emphasised by their close proximity to
the straight edge of the picture frame in
this portrait of the writer Walter Allen.

Kodak Tri-X, Nikon 105mm, 1/30th sec @
f5.6

The lines of composition in this picture
all flow to the centre. The man stands
isolated from his surroundings, head
and shoulders clearly defined against
the uniform grey of the street. The
unsharp buildings due to the limited
depth of focus, give the picture its
context without distracting from the
central figure.

Ilford HP3, Leica 35mm, 1/250th sec
@ f5.6

Facing page: **A longer focal length lens
and wide aperture throw foreground
and background out of focus. The
shouting demonstrator stands out in
sharp contrast.**

Kodak Tri-X, Pentax 135mm, 1/1000th sec
@ f4

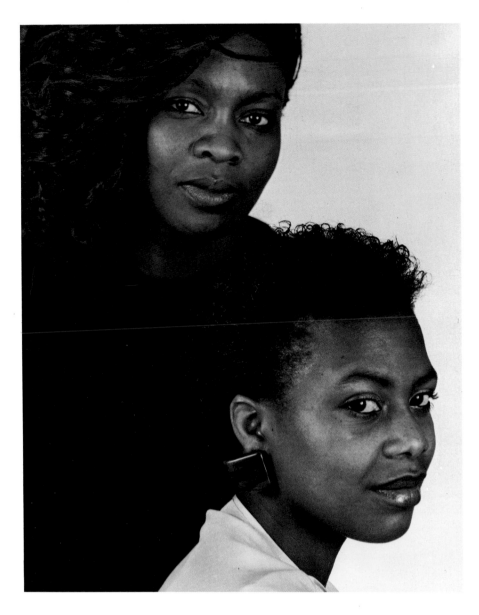

In the dual portrait the composition is the first problem to be resolved. Two heads on the same plane will lack impact. Try and place one higher than the other but retain balance so that neither assumes greater importance. If you photograph two people in normal proximity, in the finished picture they tend to look much too far apart. You need to place them closer together than would seem natural or comfortable. In this portrait, one girl is sitting on a large poufe and the other is kneeling behind her. Trying to get two people with natural expressions at the same time is going to be twice as difficult as with a single portrait, so be prepared to shoot a lot of film on the dual portrait.

Ilford HP4, Mamiya 6 x 7, 180mm, Studio flash

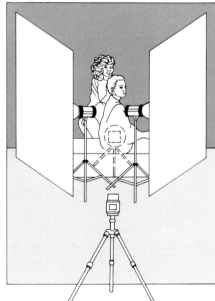

Lighting is bounced from two large reflector boards with a further light on the background

Identical twins—a case where symmetry in the composition can give an added dimension.

Kodak Tri-X, Nikon 85mm, 1/500th sec @ f8

Facing page: **A group picture, in slightly formal classroom-style, of Sir John Gielgud and Alan Bennett with the rest of the cast of 'Forty Years On'. With serried benches it is not too difficult to arrange people so that they cover the whole picture area. Where that is not possible a good solution is for the photographer to take an elevated position. This gives him an unobstructed view of each person, at the same time eliminating any disturbing background. People welcome guidance when being photographed in a group and you need to be quite firm and definite about how you wish to position them.**

Kodak Tri-X, Nikon 50mm, Daylight in the Studio

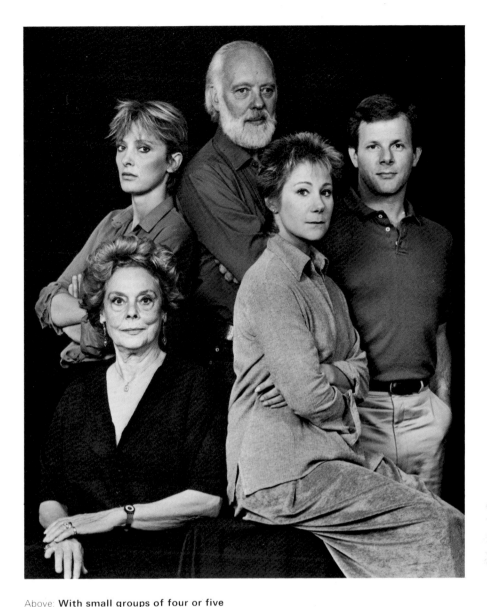

Above: **With small groups of four or five persons it is impossible to get the heads really close together. At least the upper torso will be visible, so you need to make sure that their clothes blend but do not merge into either the background or each other. It is best to ask them to bring a possible change of clothing. There is a lot going on in a group portrait so the less distracting the background the better. A plain studio backdrop is ideal. Arranging the heads in a pleasing composition can mean a lot of fine adjustments and does take time. You definitely need to have the camera on a tripod so that you can concentrate on all these elements.**

Kodak Tri-X, Mamiya 6 x 7, 180mm, Studio Flash

The Japanese musician Mitsuko Ochida
uses her bicycle whenever possible to
beat London's traffic jams. I 'panned'
the camera to get a feeling of
movement when I photographed her
cycling near her London home in
Portobello Road.

Kodak Tri-X, Nikon 85mm, 1/60th sec @ f16

Another way to create the feeling of movement when in fact the subject is quite still. Someone was holding the bike upright when i photographed champion cyclist Reg Harris and, with my camera on a tripod, 'zoomed' the lens during exposure.

Kodak Tri-X, Nikon Zoom 80-200mm, 1/8th sec @ f32

Blurred flash: music hall entertainer
Johnny Groves playing the spoons.
Adrian Franklin used flash and an
exposure of a $1/4$ of a second to get a
blurred image in the hand suggestive of
movement.

Photograph Adrian Franklin

Sporting events give wonderful opportunities for portraits of athletes at the peak of stress. You need fast, long lenses (anything up to 1000mm) and quick reactions. Knowledge and appreciation of the sport you are covering helps the photographer to anticipate the flow of movement. Two or more footballers challenging for the ball in the air is one of those moments that will show the tension and combative skill of the sport.

Kodak Tri-X, Nikon 180mm, 1/1000th sec @ f4

This superb picture, taken at a
greyhound race meeting, needed
split-second timing. Where the action is
moving towards the camera, the shutter
should be released a fraction of a
second before the image is sharp in the
viewfinder. To manage to get a close-up
of a greyhound travelling at over 30mph
so sharp that you can count each tooth,
is a singular achievement.

Photograph Chris Smith

Facing page: **Photographing ballet,
whether on stage or at rehearsal as in
this picture of Alessandra Ferris,
demands many of the same skills and
techniques used by the sports
photographer. You do not need the very
long lenses—180mm or 135mm are the
ideal focal lengths. You will need fast
lenses whenever there is action on stage
or in the rehearsal room. If necessary
you can uprate your film to 800 or even
1600 ISO.**

Kodak Tri-X rated 800 ISO, Nikon 85mm,
1/250th sec @ f2.8

Action on stage. Always use the fastest
shutter speed possible where you want
to freeze the action and avoid camera
shake. The longer the lens you use the
more difficult it is to hold steady. A
unipod is a good way to minimise the
risk of camera shake, whilst still giving
plenty of manoeuvrability.

Kodak Tri-X, Nikon 135mm, 1/500th sec
@ f2.8

106

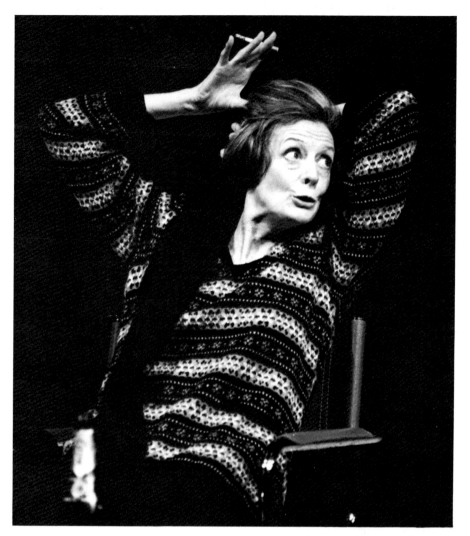

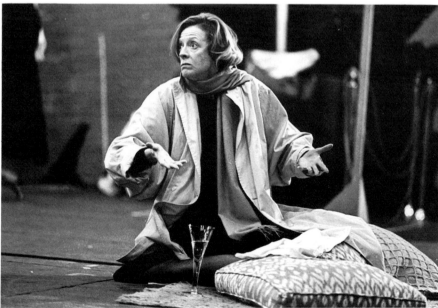

Maggie Smith on stage and during
rehearsal. Rehearsal pictures can be
very rewarding but are usually plagued
by extremely poor lighting conditions
and cluttered backgrounds.

Above: Tri-X rated 800 ISO, Nikon 180mm,
1/250th sec @ f2.8
Right: Tri-X rated 1600 ISO, Nikon 135mm,
1/125th sec @ f2

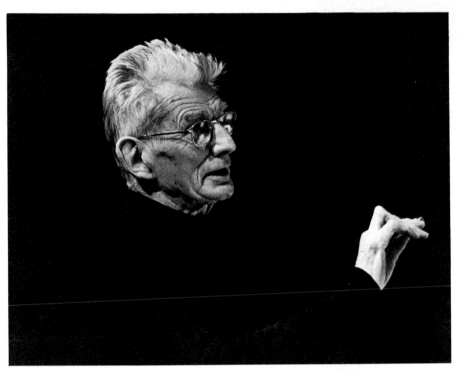

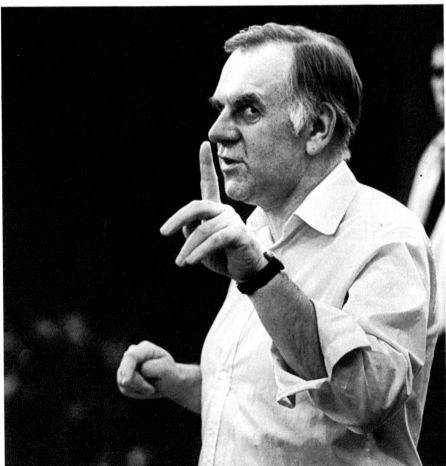

Rehearsals are rich with opportunity for the photographer looking for expression and emotion in his portraits. This is the time to photograph the director as he builds and shapes the performance of his actors. It is a real privilege to be present at an occasion which can be more interesting than the performance itself.

Above: **Samuel Becket directs 'Waiting for Godot'.**

Kodak Tri-X rated 800 ISO, Nikon 300mm, 1/250th sec @ f4

Right: **Ron Eyre directs 'A Winter's Tale'. . .**

Kodak Tri-X rated 1000 ISO, Nikon 50mm, 1/60th sec @ f2

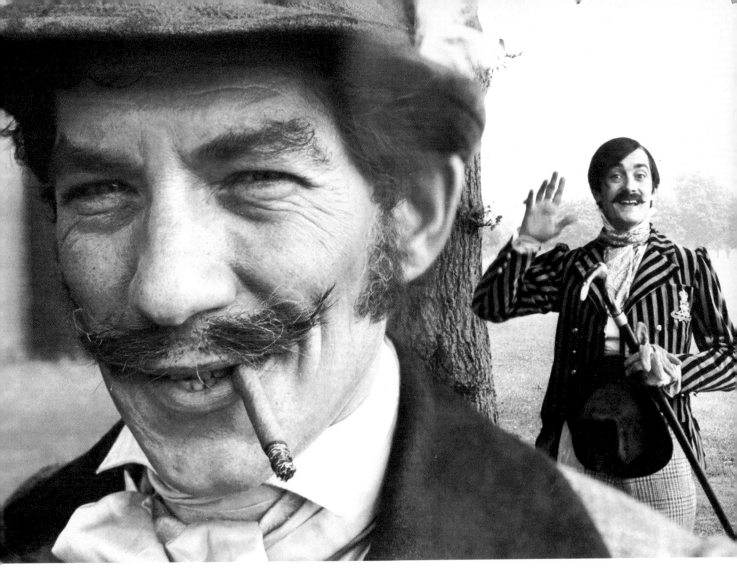

The split level dioptre is an excellent
device when you want a bold head in
the foreground and the background in
focus. It is, in fact, a close-up lens
placed over one half of the camera lens
and needs to be used with care, so that
the transition from foreground to
background focus is not too obvious. In
the above example, the transition point
is where the tree and the ear meet.

Kodak Tri-X, Nikon 50mm, 1/125th sec @
f11, Split-Level Dioptre

The Unawares Portrait

The world is full of wonderful pictures, peopled by wonderful characters who will make wonderful portraits. You see them every day all around you and in your mind's eye take the best pictures you ever knew. The great problem is, that as soon as you produce your camera and start focusing for the picture, your subject becomes aware, self conscious, maybe irritated or, even worse, puts on an ingratiating smile. The human being, natural, at ease and unaware of being observed, is lost and so is the picture you were hoping to record.

The unobserved photographer is epitomised by Henri Cartier Bresson, the photographer who seems to be able to come so close to his subject and yet remain unnoticed. He has said little if anything about his methods, deliberately so, because he wishes to remain as anonymous as possible. He tries to avoid having his own picture taken for publication and gives no interviews. We do know he uses a Leica for its immediacy and quietness of shutter (there is no mirror to contend with in a rangefinder camera). As mentioned in a previous chapter, Cartier Bresson was the photographer who covered the shiny parts of his camera with black tape to make it as unobtrusive as possible.

There is always an element of hunting your quarry when taking portraits of people without their being aware. There is a challenge and excitement about it, with subterfuge, cunning and a lot of patience as the main ingredients. If you want to get that image onto celluloid with enough determination you will find a way.

Always have your camera at the ready hanging around your neck, focused at 10 feet and set at the average setting (unless your camera has the advantage of automatic metering). An open raincoat or jacket is ideal for the camera to remain partly hidden. At all costs avoid the situation whereby you start fumbling for the camera, applying lens hood etc. and drawing attention to yourself at the moment when you decide to take a picture. In a fast-moving situation it is better to shoot first and then, if you get a second opportunity, check focus and exposure, rather than risk losing the picture altogether.

Your choice of equipment needs to be considered quite carefully before you set off on your quest. A camera that used to be very popular, the twin-lens Reflex with waist-level viewfinder, was also very suited to this type of photography. The camera is less noticeable when used from the waist. You can turn the camera sideways and view your subject through the viewfinder whilst apparently only interested in some object in front of you. A similar effect can be obtained with 35-mm SLR cameras, by the use of a gadget incorporating a mirror which screws onto the front of your lens. There are two different types available depending on the focal length of your lens. They both reflect the image through an angle of 90 degrees but due to their strange appearance may be the cause of the very interest you wish to avoid.

These methods of working begin to sound a bit like something out of a spy manual. In fact, you will be surprised at the way in which you can point your camera at someone and yet, by focusing your attention on some object just behind them, allay their justified fears that they are the object of your attention. The really important thing is to avoid any eye to eye contact with the person you are trying to photograph.

Of course this does pre-suppose that there is some activity in the vicinity of your chosen subject. With the Andy Capp impersonation, whom I spotted on the beach at Clacton, he was too isolated a figure to fool by this method. Instead I made use of the unrestricted space around him and used a 500-mm lens at a distance which meant that he was unaware of my activities. On the other hand, the couple asleep on their deck chairs were easy prey. Only the noise of the camera shutter could give you away in these circumstances and a noisy motor or automatic camera wind is definitely something to leave behind.

People absorbed by some activity, whether as spectators or participants, are subjects most likely to remain unaware of the photographer. Expressions from elation to dismay can be captured on the faces of spectators to some exciting sporting event. As long as you do not obstruct their view of the proceedings, they will be far too involved to notice you. Try to pick out a likely face in the crowd near the winning post at a race meeting at the moment when the action reaches its peak. Look out also for the contrast—the face of someone, too drunk to care, in a sea of excited expressions. I was once sent to a race meeting in Ireland with that type of picture in mind (it was an assignment for the Irish Tourist Board). After a fruitless search for the genuine article, I was reduced to setting up the picture and, like so many 'set ups', it lacked authenticity. But this idea of contrasts, the distracted amongst the involved, the tearful amongst the rejoicing, are all strong picture possibilities.

In a crowd you can work with normal or even wide-angle lenses. People do not realise the capabilities of a wide-angle lens and so you can be photographing someone on the edge of the frame who would feel certain that he was beyond the range of your camera.

Neil Libbert has been using a similar technique over a long-term project, photographing people at DHSS offices. The DHSS take a dim view of anyone photographing on their premises but

even so, Libbert has managed to get some stunning pictures of the resignation, the boredom and anxiety as people wait for their hand-outs. The rangefinder has always been his favourite camera. He uses a 35-mm and particularly a 21-mm wide-angle lens and presets focus and exposure. He fires the camera from chest height without raising it to his eye. By trial and error, he has become extremely accurate at framing his subjects and with such a wide-angle lens, there is scope for a margin of error. So far no one has been aware of being photographed.

If you do find a place where people gather to talk, such as a park bench, town square or harbour area, try positioning yourself on the perimeter, in some unnoticed doorway. Be prepared for a long wait and make yourself as comfortable as possible. A zoom lens is ideal for this situation. You are in a fixed position and there is no telling exactly where the best groups are going to be. Of course this set-up will not work in a crowded area. You must have good sight lines when working with a long lens.

Inevitably there will come times when your subterfuge doesn't work and your subject becomes animated, embarassed or annoyed because of what he perceives as an intrusion of his privacy. In fact photography in public places is perfectly legal. The only grounds for litigation would be if you published a photograph that made someone look so ridiculous that it could be proved to damage his reputation. I've never heard of anyone bringing such a case. Reactions to being photographed are much more likely to be positive than negative but the picture you were hoping for is lost even so. On occasions it is the reaction to the camera that actually makes the picture.

This is especially true with children, as in the case of the little girl in the Birmingham slum. Her reaction seems to show a spontaneity and resilience that defy the conditions. Children do tend to swarm all over you particularly when they're in groups and in warm foreign climates. It's best to take a few shots, even if you are only pretending by flicking the depth of focus preview button. After a while the novelty will wear off and they will return to their activities. Once your presence has become routine and accepted, you can get down to photographing them without the commotion. The only times photography becomes impossible are those where tourism has put a price on the act of picture taking. A gift is demanded and when received will be rewarded with a sickly smile. In these circumstances you might as well forget taking pictures.

There are occasions where only the direct approach will enable you to get the picture you are after. I was driving down a country lane in Dorset when I spotted this rabbit farmer cutting vegetation from the hedgerows. I stopped the car and walked back to where he was. As the only person in sight, there was no way of photographing him unobserved. I asked if he minded my taking pictures and he was extremely co-operative. He was even willing to do some more cutting although his task had just been completed. In the picture I liked the best, there is no doubt of his awareness of the camera but his involvement is not disguised. It is those small boots compared to the great bulk of the man, that do seem to express the character of this gentle giant and it needed a plain background, such as is provided by the tarmac road, to bring that out clearly. In situations like this, where someone has been friendly and co-operative, do take their address and send them a print wherever possible.

I joined a group of men in a street corner conversation and was able to capture this knobbly profile without interrupting the flow of talk.

Kodachrome 64, Leica 35mm, 1/125th sec @ f4

This holy man in Nepal was quite
oblivious to all around him and though
he looks into the camera his expression
is quite unmoved.

Kodachrome 64. Nikon 85mm, 1/250th sec
@ f5.6

Facing page: **These ladies sunbathing in
Leningrad were too pre-occupied to
notice me at first and only showed their
impatience after I had made several
exposures. I did feel intrusive but my
photographer's instincts overcame any
other sensibilities.**

Kodachrome 64. Nikon 85mm, 1/250th sec
@ f5.6

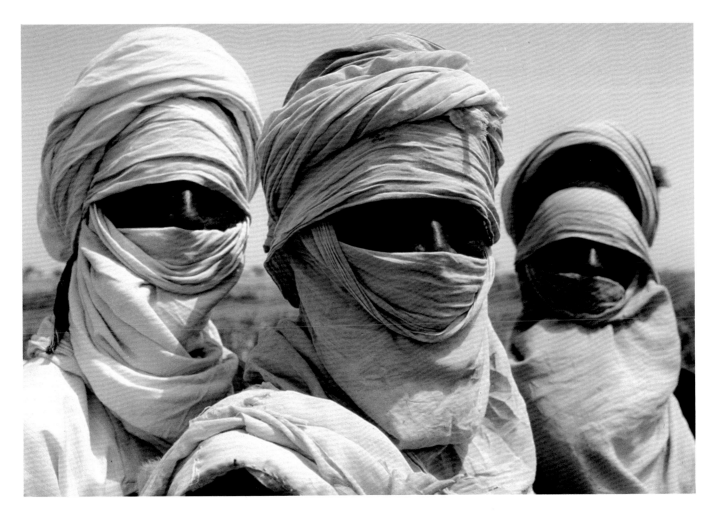

When you are unable to see your
subject's eyes, it is difficult to know
how he is reacting to the camera's
presence. The Tuareg tribesmen in this
picture were part of a group listening to
an aid worker and happily they retained
the pose as I produced my camera. You
try to photograph people unaware of
the camera's presence in order to
portray them as naturally as possible. In
some situations you just have to declare
yourself and count it as a bonus if there
is little or no reaction.

Kodachrome 64, Nikon 85mm, 1/250th sec
@ f8

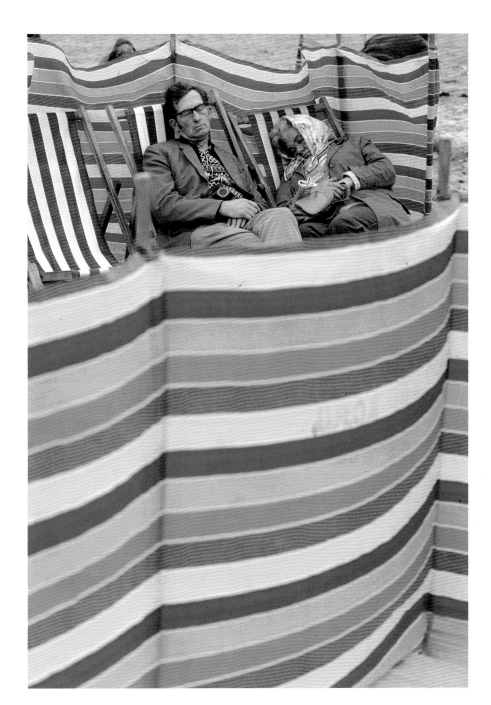

With this sleeping couple, the only thing to give my presence away would be the click of the camera shutter. The rangefinder camera is very quiet as there is no mirror to contend with. It is worth bearing in mind in certain situations.

Kodachrome 64, Leica 90mm, 1/125th sec @ f5.6

The only way to get an unawares
portrait of this man on the beach at
Clacton was if I was far enough away
for him not to notice my presence. With
a 500mm mirror lens I still had a bold
image from 30 yards away.

Kodak Tri-X, Nikon 500mm, 1/1000th sec
@ f8

Auction day at Sotheby's. Plenty of opportunities for juxtaposing objects with the participants.

Kodak Tri-X, Nikon 50mm, 1/60th sec @ f2.8

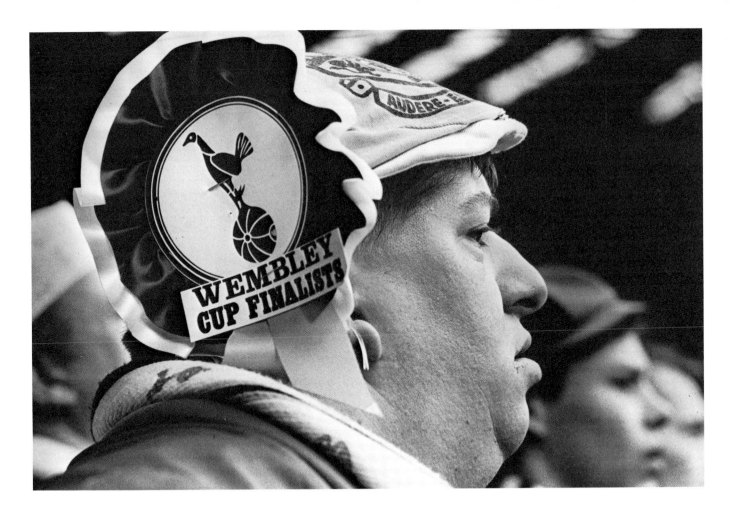

It's always fun to concentrate on a
single face amongst a throng of
spectators. Their absorption in whatever
activity it is they are watching usually
means you can work without fear of
detection.

Kodak Tri-X, Nikon 85mm, 1/250th sec @ f8

Absorbed as she was in placing her commemorative crosses at Westminster Abbey on Armistice Day, I had no difficulty photographing this lady unobserved and used a fairly long focal length lens to throw the background out of focus.

Kodak Tri-X, Nikon 180mm, 1/500th sec @ f4

Photographer Neil Libbert developed his
own technique to capture the boredom
and isolation of those waiting for hours
at **DHSS** offices. On his numerous visits,
none of his subjects has ever been
aware that he was taking their
photograph.

Photograph Neil Libbert

Facing page: **For this picture I settled
down in a doorway in the religious
district of Jerusalem and just waited for
things to happen, knowing that it was a
favoured meeting place. A zoom lens is
useful in this type of situation where
you are uncertain at what distance your
subject will be.**

Kodak Tri-X, Nikon 85-200mm zoom,
1/500th sec @ f5.6

Birmingham slum. Sometimes the spontaneous reaction to the camera can make the picture.

Kodak Tri-X, Nikon 105mm, 1/250th sec @ f11

The horseguards will sit for you as still
as a painter's model but the tourists
around them may make the better
picture.

I spotted this splendid gentle giant when driving in the back lanes of Dorset. There was no way of photographing him unobserved but he was more than happy to let me take his photograph. You never know until you ask.

Kodak Tri-X, Nikon 50mm, 1/60th sec @ f4

Family Portraits

One source of photographic portraits is the family album. We all enjoy looking at pictures, taken long past, of our relatives smartly dressed and showing their best face to the world. We try and see the family resemblance, passed down through generations but more than that, we recall a time and a period which turns that interest into a more universal one. Fascinating to see the clothes worn, the furniture and the artifacts used. Think back to the end of the last century when the family portrait session was a big event. It occurred, for the most part, on the important occasions in people's lives—marriage, birth and the main anniversaries. The photographer and his subjects took the whole occasion very seriously and although there is a ponderous quality in the results, at the same time they work as pictures and are full of information to intrigue future generations.

This is a relaxed age, an informal age and these different approaches to life are reflected, inevitably, in the type of pictures that we take. I miss the arranged portrait for the special occasion, with its studied and serene quality. At the same time. I wish my forebears had been able to hand down some of the lively, spontaneous pictures that modern techniques have now enabled us to accomplish—accomplishments that we know exist but are, all too seldom, evident amongst the family albums of our friends. Perhaps the very ease of manipulation of the modern autofocus camera has meant that people think less about the sort of picture they are taking and end up with such a bulk of monotonous, cluttered and confusing images. Far better to take rather less random pictures and produce more with care and a lasting quality.

Babies and Toddlers

Until your child is about six months old and able to sit up and start focusing on the world about him, your choice of pictures will be limited to the mother and child variety. You will want a record of the newly-born child but quite honestly, I marvel more at the perfectly formed hands and feet, rather than the face, so reminiscent of a wizened old sage. The baby's head needs to be supported by someone and the best pictures are those where the faces of baby and mother are brought together, close or even touching, in the most natural looking way. From six months on things begin to happen very fast. The baby will soon be crawling all over the place and you had better get down on your hands and knees and start crawling as well. There is nothing worse than lots of pictures looking down on your child from on high. Once the crawling stage is upon you, it's time to start thinking about action pictures. For this bounced flash is ideal—you freeze the action and the even, overall illumination means that you do not have to concern yourself in which direction the baby is facing. Set the flash on a lighting stand with an extension lead to camera, rather than firing the flash directly from the camera. This allows you more freedom of movement. Unless the walls are white, bounced flash will cause a cast with colour film, in which case use an umbrella. The lighting will be somewhat more directional but the colour rendition will be correct.

The Picture Sequence

For the next few years your children will be discovering the world. Watch out for the possibility of the picture sequence that can be created out of the most mundane childhood discoveries. My own two favourites were how to get into a tub of water and how to put on a vest. The sense of achievement on the child's face when the mission has been successful is the real pay off. But pictures of children don't always need to be of the happy and smiling variety. Childhood also involves shyness, hurt and pain and as a photographer you should be ready to record those emotions as well. The great joy of photographing children and especially your own, is the lack of subterfuge—the willingness, after an initial bout of wide-eyed inquiry, to get on with whatever interests them. The presence of a camera will not alter their behaviour in any way, as long as it is not expected of them and they are not being cajoled and directed by an anxious parent.

Other People's Children

Although not self conscious in front of the camera, children other than your own may be very shy and withdrawn at the prospect of havng their picture taken by a strange, unknown man. The first part of any session must involve winning their confidence. Once that hurdle has been overcome, the same ground rules apply as with your own children. Get down to their level and join in the fun. Matters of technique, such as exposure and lighting, should be simplified so that you don't need to strain the children's patience by asking them to 'hold it'. A picture session has to be enjoyed by both sides. There can be no question of compunction or it is bound to show in the finished product. Remember, one of the best-known photographic images of the 20th

The spontaneity of contemporary portraits and family groups is lacking in Victorian photographs. They make up for it with perfectly judged compositions and great attention to detail, full of information to arouse the interest of later generations.

The perfectly formed feet of a one-week-old baby are as appealing as any other part of the anatomy.

Kodak Tri-X, Nikon 50mm, 1/60th sec @ f2

century is a picture Eugene Smith took of his own two children. They are seen walking hand in hand out of a clearing in the trees—from darkness into light. The thing which gives the picture its strong symbolic quality is that the children have been photographed from behind. They are not just his children, they are everyone's children as they start on their voyage of discovery. It makes the point that there are great pictures to be had, even in your own back garden.

As with adult portraiture, you do require the direct look into camera. Once the child has accepted you as part of the general activity, it's just necessary to call his name at selected moments. He will turn or look up into the camera and you must be ready to catch that expression of surpise, puzzlement, delight. Whatever it is, it will be spontaneous and last for just a moment.

The Action Portrait

Children make great subjects for all kinds of action pictures. Try using some of the techniques discussed in Chapter 8. The swings and roundabouts of the playground are ideal for the blurred action shot through panning or the lens 'zoomed' during exposure. Where you want to freeze the action try and pick out activities, such as the high jump, where you can focus on a pre-selected spot and press the shutter at the moment the child reaches that spot. Children love having their picture taken when they are performing in some way (as do adults) and they will be only too keen to co-operate with you. Having a fast enough shutter speed is only one problem with action pictures. The real difficulty is getting the subject in focus. You can make a game by asking the child to jump, turn, look into camera or even do all three together, at a pre-arranged spot. Either make a mark on the ground or select some clearly defined object to pre-focus on. In almost every case, the longer focal length lens will give you a more effective result by clearly separat-

ing your subject from the background. You are also better able to control the size and movement of the image in the viewfinder, when you are some distance away from your subject. When photographing movement, bear in mind that action moving across the picture frame will require a faster shutter speed than action coming towards the camera.

Teenagers

The heyday of photographing your children is drawing to a close. All sorts of inhibitions and resentments are beginning to surface. Privacy is jealously guarded and adolescence is often a very painful period in a person's life. No matter how tactfully you photographed them in the past, with the minimum amount of compunction, from now on it is going to be much more difficult to get their willing co-operation. In any case this is a time when your own interest in photography can be passed on. There aren't many young people who don't, at some stage, want to try their hand at photography. The excitement of watching one of your pictures slowly appear, like magic, in the developing dish, is one of the best ways to kindle that interest. The family album can now be filled with their own pictures of the outlandish clothes they choose to wear, the cars they are learning to drive and all the other things that will be so rewarding to look back on in years to come.

The Elderly

The bond between grandparents and their grandchildren is a very special one and full of opportunities to take photographs which appeal beyond the confines of the family circle. It is a difficult picture to pose or arrange but one that should come about through the natural relationship that exists between the two. For this reason it is probably better to put yourself as far in the background as the situation will allow. This has the double advantage of allowing the relationship to flourish undistur-

bed and, through the use of a telephoto lens, flattening the image. This will help to give the appearance of closeness between the two figures where a wider angle lens would accentuate the distance between them.

Not many of us can come to terms with how we look as we approach old age. For this reason a full length portrait may be the best way of photographing the elders in the family. If you do wish to take a head and shoulders portrait, you have a choice between the uncompromising attitude of a Richard Avedon, who made a feature of every line in his father's face, and a soft-focus filter effect. As with all things, compromise is possible and you will have to see how far you can go with soft lighting and retouching of lines and wrinkles, without losing the essential likeness. What really counts is the sparkle in the eye.

Family Groups

On those occasions when the family does assemble, you will have a chance to put into practice the things that have been mentioned on photographing groups in Chapter 8. The difference here is that you, the photographer, are also a member of the family and need to be part of the group picture. If you have a delayed action device on your camera, the problem can be nicely solved by placing the camera on a tripod and arranging the group, so there is a place for you, convenient to the camera. Once you have depressed the shutter button, you will have on average eight seconds to get into place, before the shutter is triggered. It should be ample time but I do suggest two or three exposures to allow for the possibility of someone blinking during exposure. Without a delayed action device, I am afraid you will be reduced to searching for a friendly neighbour to take the picture for you.

Facing page: **The more formal studio portrait. It is up to the ingenuity of the photographer to find different ways of getting the heads of mother and child in close proximity, in a way that looks natural and comfortable. This may be the opposite to the way it feels to the participants.**

Ilford FP4, Mamiya 6 x 7, 110mm, Studio flash

Watch your children discover the world
and try to capture the sequence in
pictures. My daughter's delight in
finding her way into a tub of water for
the first time, was well worth
recording.

Kodak Tri-X, Nikon 105mm, 1/500th sec
@ f11

Facing page:
**The relationship between mother and
child gives endless opportunities.**

Kodak Tri-X, Nikon 105mm, 1/250th sec @ f8

Children love posing for the camera and after the initial excitement, the natural grace and dignity of their personality will emerge.

Kodak Tri-X, Nikon 105mm, 1/30th sec @ f5.6

Facing page: **A child's mood can change very suddenly. The sad or bewildered can make as compelling a portrait as the happy, smiling face.**

Kodak Tri-X, Pentax 135mm, 1/60th sec @ f4

It's quite an achievement the first time a
four year old puts on a vest. Another
chance for a good picture sequence.

Kodak Tri-X, Nikon 85mm, 1/60th sec @ f5.6

This is the sort of intimate family
grouping that would never look right if
you tried to set it up. It's worth having
your camera at the ready for moments
such as this.

Kodachrome 64, Nikon 35mm, 1/125th sec
@ f5.6

Mother and child pictures abound. This
one is helped by the monotone
background which keeps the image
clear and simple.

Kodachrome 64, Nikon 85mm, 1/125th sec
@ f5.6

Another picture strengthened by the uniform background—snow is marvellous for covering unwanted detail.

Kodachrome 64, Nikon 105mm, 1/250th sec @ f5.6

Rehearsing for the school concert.
Children absorbed in their activities are
excellent subjects but lighting can be a
problem, especially in colour. In this
case I used photofloods to overcome the
colour cast associated with fluorescent
tubes.

Kodachrome Type A, Nikon 50mm, 1/60th
sec @ f2.8

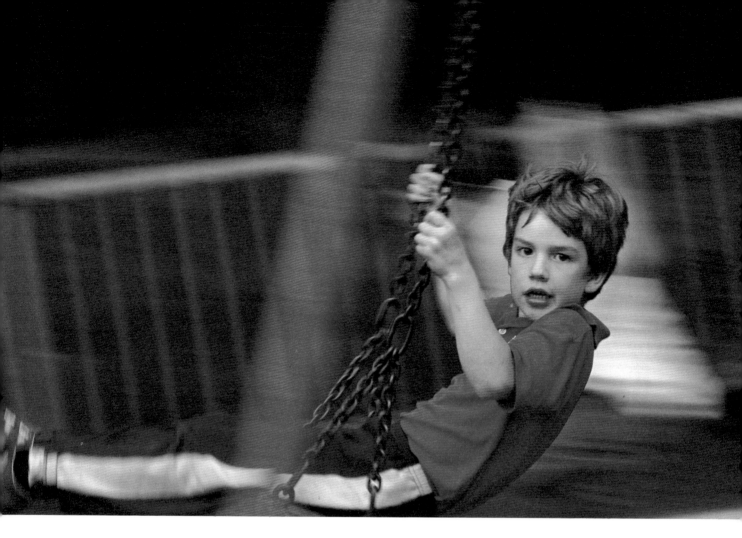

The panned shot is easier to control
with fast-moving objects. The camera
needs to move in unison with the
subject in order to create the blurred
background. In the playground the
swings are the most suitable for
creating this sense of movement but
remember that the peak of action is
when the swing is nearest the ground.

Ektachrome 100, Nikon 85mm, 1/60th sec
@ f5.6

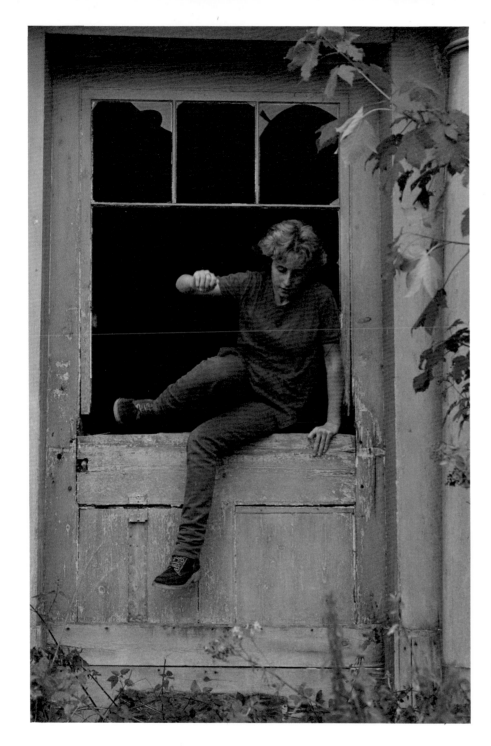

Take advantage of natural ways of adding a frame to your composition. The most obvious is the doorway or window as here.

Kodachrome 64, Nikon 85mm, 1/250th sec @ f4

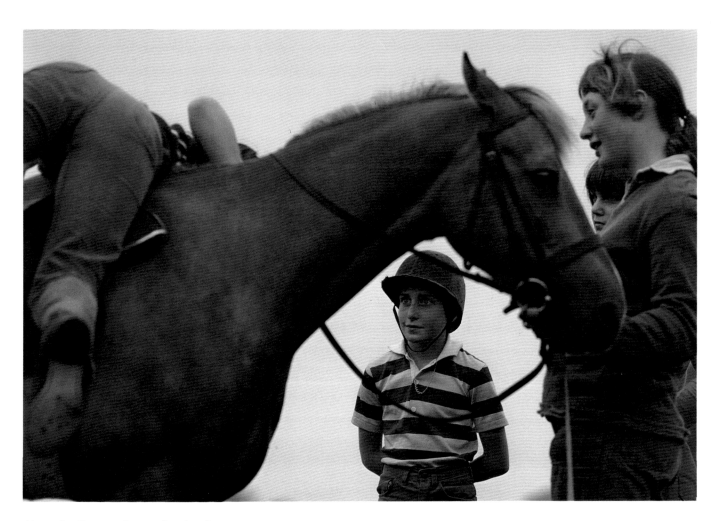

Above: **Another good example whereby
the composition is strengthened, this
time by foreground framing.**

Kodachrome 64, Nikon 85mm, 1/250th sec
@ f4

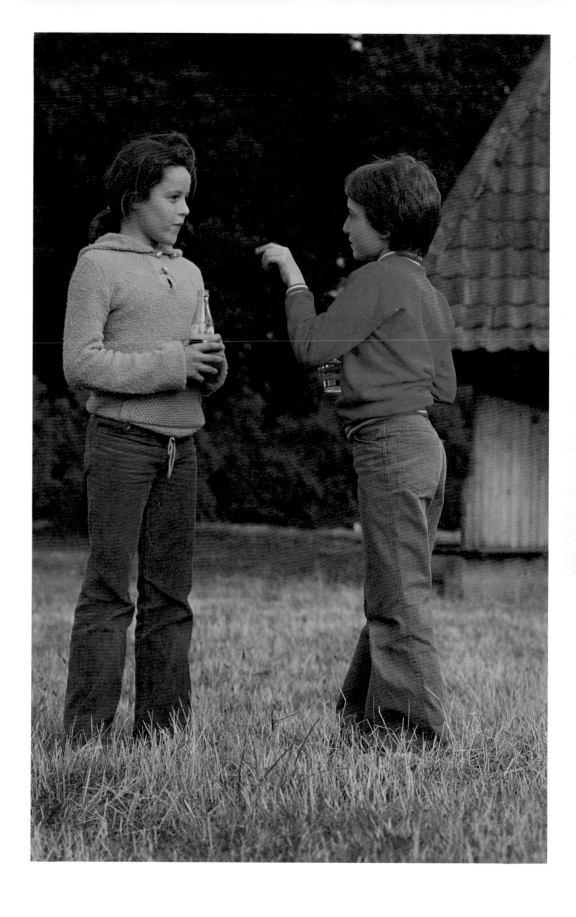

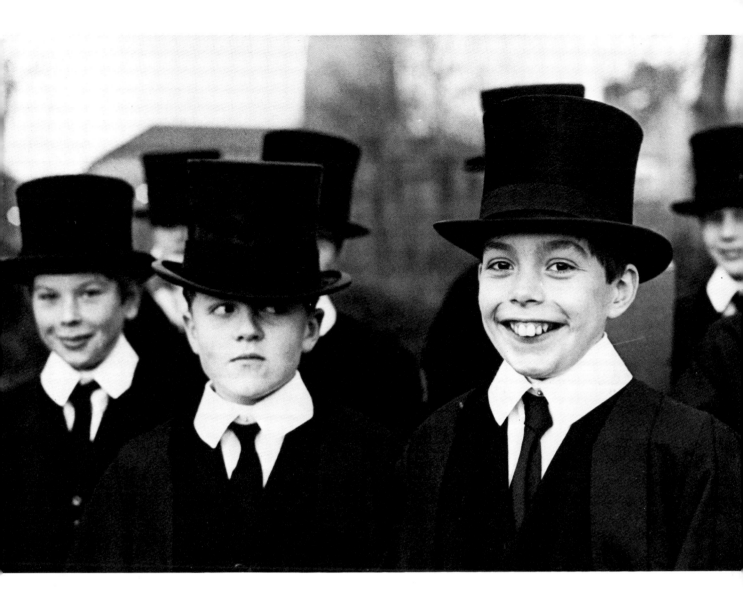

Dressing up, whatever the occasion, is always worth a photograph. These are boys from King's College, Cambridge due to sing in the choir for the Christmas broadcast of carols.

Kodak Tri-X, Nikon 50mm, 1/250th sec @ f4

Facing page: If the family is quite used to the camera and you haven't alienated them by demanding their attention too often, then your choice of getting intimate, unposed moments will be all the greater.

Kodachrome 64, Nikon 85mm, 1/250th sec @ f4

Mutual involvement in some activity, as here on the beachfront at Blackpool.

Kodachrome 64, Nikon 85mm, 1/250th sec @ f4

Facing page: **Children with their grandparents. The picture possibilities abound in a relationship which, apart from its emotional connotations, can be so revealing in the physical comparisons.**

Kodachrome 64, Nikon 85mm, 1/125th sec @ f5.6

The atmosphere of a room has pictorial
and nostalgic qualities of its own as
well as adding information about the
person whose room it is. If the picture is
taken by daylight, as here, the colour
temperature may vary according to the
colour of walls and furnishings and is
not as easily predictable as using flash.

Kodachrome 64 Nikon 35mm 1/15 sec. @
f5.6

The environmental portrait may be
kinder to the individual. Posing elderly
people in relation to their surroundings
leaves more emphasis on the setting.
Balancing the light between indoors and
outside needs careful consideration.
With colour you will need to use flash
for the correct colour balance. Decide
on the required aperture for the flash
reading and then set the exposure time
by metering the outside.

Ektachrome 100, Mamiya 6 x 7, $^1/_2$ sec
@ f11. Flash + daylight

Facing page: Character lines are deeply established with age and whilst giving weight to the portrait, may not always please the subject. Soft light and printing on soft paper may be one solution, as here. You may want to go further and use soft-focus filters or the trusted 15 denier nylon over the lens, to smooth away those universal signs of ageing.

Kodak Tri-X, Mamiya 6 x 7, 180mm, 1/4 sec @ f5.6

Above: Finding a suitable setting to place your family group is nine tenths of the problem. Steps, such as those here, are ideal. Try and find a spot in the shade with even, shadow-free lighting. Don't expect people to face strong sunlight which will cause them to squint. If you want to place yourself in the photograph, a delayed action device on the camera will give you about 8 seconds from starting the shutter release, to getting in a pre-selected position.

Kodak Tri-X, Nikon 50mm, 1/60th sec @ f11

Picking the Right Picture

The idea that once you have created the image in the viewfinder, the rest of the process is a purely mechanical one, is the very opposite from the truth. Certainly if the original image is poor, there is very little that you can do that will turn it into a good one, but where the take has been successful, a lot of the creative input may be still to come. Most of us use our camera as a painter would use a sketch book. We play around the image, fine tuning it and continually searching for ways to improve it, at each stage exposing yet another frame. In portraiture there is the continual compromise between the deliberate pose, carefully arranged, and the spontaneity of expression, fleetingly caught.

Once the portrait session is over, we have the choice of developing the material ourselves or sending it out to a laboratory. With colour material I would recommend the latter. The mechanics of colour development demand a degree of control over temperature and chemicals that is best left to the specialist laboratory. The cost of maintaining constantly fresh chemicals means that on economic grounds alone, home development is at a disadvantage. Black and white, with its far greater latitude, is the medium I wish to concentrate on when talking about printing and developing in your own home.

The Darkroom

A temporary darkroom can always be set up by blacking out bathroom windows. If you do possess a large closet this could be converted quite easily, a sink being the most important item to install. Failing this you would need a pail of water to transport fixed prints and negatives to the bathroom for a final wash in running water. Ventilation is also something you would have to attend to in so confined a space. Probably the best solution is to partition

a room so that you have darkroom adjacent to finishing, working and storage area. The minimum size for one person to work comfortably, to have room for enlarger, three 15 x 12 inch dishes and a sink, is 9'6" x 3'6". Two black felt curtains over the entrance will be quite adequate in ensuring total darkness. When installing your safelight, it is a good idea to have a separate white light with a pull switch (your hands are often wet in the darkroom) over the fixing bath for immediate inspection of prints.

Contact Prints

With darkroom installed and film developed, dry the film (hair dryer useful here) and then cut into strips so that they cover a 10 x 8 sheet of bromide photographic paper and expose this under light from the enlarger. In order to ensure close contact between negative and paper (and thereby sharp results) you will need to place a heavy clean sheet of glass, preferably with bevelled edges, over them. Always place emulsion side of negatives to the emulsion side of paper. Contact prints are essential, particularly in portraiture, before proceeding to the final enlargement. With experience you may be able to judge many of the picture's qualities from the negative, but never the nuances of someone's expression.

You now come to what should be one of the most pleasurable aspects of the whole process—selection of the final image. You need a magnifying glass and two L-shaped pieces of card to help you determine the crop and tilt of the final picture and a chinagraph pencil to outline your crop on the selected contact prints. It is often said that the photographer is not the best person to select his own contacts. He cannot be dispassionate enough, he is too involved with the image he remembers in the

viewfinder rather than the actuality of the developed result. A lot of the creative side of picture taking is very instinctive, whereas picture selection is more analytical. But it is still a part of the creative process and as such I would always argue for the photographer's involvement. At best he should be in a position to discuss his choice with someone whose opinion he respects. There is nothing final in the initial selection of contacts. If the enlarged print does not come up to expectations, you can always go back to your original take and try out a different image. With portraiture it is often advisable not to crop the image too tightly in the viewfinder at the moment of exposure. This gives you a certain leeway in tilting the image at the enlarging stage and creating a more dynamic, arresting image. The fine tuning of the composition is very much easier to control at this later stage.

Enlarging

Enlarging is a fairly straightforward process, the mechanics of which can be learned in an afternoon. To become a really first rate printer can take years of practice. Some photographers involve themselves totally in the print making process. Bill Brandt and Eugene Smith were two such for whom working on the enlargement was a vital part of the whole process. Others like Cartier Bresson, may feel that the creative process is purely in the picture taking. His pictures are always printed full frame and he will never allow any cropping of his images. If he did not get it right at the moment of exposure, he undoubtedly feels that no amount of tampering with the image afterwards, is going to improve things.

The technical skill in printing lies in obtaining a full range of tones, from deepest black to purest white, and still

to retain detail in the highlight and the shadow areas. The creative skill lies in matching the print to the mood and atmosphere of the picture. For instance, the high key style of certain lighting could be quite lost at the print stage if the printer was insensitive to the effects the photographer was trying to achieve.

Photographic paper comes in varying degrees of contrast, from Grade 1 which is soft to Grade 5 which is extra hard. With experience you will be able, from viewing the negative, to ascertain which grade of paper is best suited to that particular negative. As a rough guide, a thin under-exposed negative will require a hard paper, where a heavy over-exposed negative will require a soft paper. There are also papers called Multigrade which vary in contrast by being exposed through a range of filters from 1 to 10. With Multigrade there is less chance of wastage as you only need to stock the one grade of paper.

Another important element in enlarging is the technique of printing-in or shading light areas and holding back darker areas in order to reveal detail. This is called 'shading' and 'dodging' and practically every print can be improved to some degree by this method. For shading cut out the required size hole in a piece of cardboard. After making the initial exposure you direct light from the enlarger through the hole and onto the area that you wish to darken. For dodging, you need to cut out two or three different shaped and sized pieces of cardboard and attach them to a strong piece of wire. During exposure you select the appropriate shape and hold it in the light from the enlarger so that it shields the selected area from exposure. Always move the cardboard during exposure so that no clear edges become apparent where you have applied this technique.

Corrections

Once the print is developed and in the fixer, it is ready to be inspected by clear white light or better still by the light in which it will be ultimately viewed—daylight. At all events no serious judgement of the print's quality can be made under the darkroom safelight. After inspection, you may well decide to reprint but if it is just a question of lightening an area, or reducing as it is called, then there is another solution at hand. After washing, the print may be treated in Farmers Reducer which is a combination of solution A Plain Hypo,

and solution B Potassium Ferricyanide. Stored separately in crystalised form, these chemicals will keep indefinitely but once mixed together they are effective for only a very short span of time. When mixed together you will find that the more solution B present, the more rapid the action. For easy control of the process mix 100cc of solution A with 6cc of solution B in 100cc of water. Take the print to be treated from the wash and place on a flat surface (a bevelled pane of glass is ideal). Using a swab of cotton wool, you dab the 'ferri' onto the print area you wish to lighten and then wash off immediately in running water. Repeat this many times until the desired degree of lightening has been achieved. Do not leave the ferri on the print for any length of time or the results will be cloudy and uneven. Continue the process for long enough and no trace of the image will remain; thus you can completely removed the image from an area. Use a fine brush rather than the cotton wool where the area you wish to treat is very localised.

Retouching

Dust on the negative, or on the negative carrier where this is of glass, will show up in the finished print as minute white spots. Scratches and dust on the film at the time of exposure will show up as black marks. Use anti-static aerosol spray if you use a glass negative holder and clean the film with a soft brush. The blemishes that do get by can be treated by spotting and knifing. For spotting, moisten a fine sable brush with your tongue and then twirl to a point in the spotting medium which comes in various tones to match that of your paper. Now dab successively on the offending spot. Saliva seems to be the ideal solution for getting the dye to stick to the print's surface. It is certainly very convenient but you could try wetting agent as a possible alternative.

A number 11 surgeon's scalpel (available from art shops) is ideal for knifing. The blade must be perfectly sharp. Either discard and replace or else have a sharpening stone available. With very gentle sweeping motions you scratch away the surface of the print. Apart from removing blemishes, small areas can be highlighted. The effects of knifing and spotting are visible on the finished print when viewed at an angle but if it is intended for publication, the tell-tale marks will not be apparent. I have seen a Bill Brandt original print

where a statue photographed in winter had been outlined by knifing to enhance the stunning effect of a thick hoar frost.

Presentation

With modern resin-coated paper you get a perfectly flat, even print. The more attractive fibre-based papers are more difficult to dry out evenly. In either case the finished result will be improved by mounting on thick cardboard. The ideal method is to use a dry mounting press but this adds yet another expensive item to your shopping list. There are now some very good aerosol adhesives on the market and although this is a more laborious way of dry mounting, the end results can be perfectly satisfactory. If you wish the photograph to be flush with the mount, do not trim the picture until it is mounted. By trimming mount and photograph together, you will obtain a much more satisfying edge than would otherwise be possible.

A large white border which isolates the picture from its surroundings and gives it room to breathe will always enhance the picture, whereas a narrow white border is merely decorative and tends to distract from the image. Where a large white border is used, many photographers 'seal' the image with a thin black line and this can look very effective. There are two methods of doing this. If you have a glassless film holder, you would have to increase its size with a file so that the projected image includes a portion of the clear film surround. With a glass film holder the black paper mask would have to be similarly enlarged. However where you wish to crop the negative this system will not suffice. In this case cut out a piece of black board very slightly smaller than the picture on the easel. After making your exposure, remove the negative from the enlarger. Now position the black card carefully over your exposed sheet of enlarging paper. Turn on the enlarger and fog the exposed rim of your enlargement. You can always tell which method has been used by looking at the corners of the print. A negative has slightly rounded corners where those of the cardboard are rectangular.

For the home, a framed photograph is ideal, whether to hang on a wall or stand on a table. The choice available in stores seems endless but never very satisfactory. I think the Victorians and the Edwardians with their innate sense of decoration are still the best source of picture frames which can often be found

quite cheaply even today.

When it comes to colour slides, these will be used either for slide shows or publication. Presentation matters only in so far as you wish to impress a prospective client with your initial display. The usual way of showing transparencies after they have been cut and placed in the appropriate mounts (cardboard, plastic or glass) is in plastic sheets with pockets for 20 or 25 individual 35-mm slides (the pocket sizes vary according to film-format requirements). A more impressive way of showing your best work is in individual black mounts which fit into plastic envelopes 9 x 12 cm. A 40 x 25-cm black card with apertures of the appropriate film size is also a good method of displaying a selection of slides with a common theme.

Storage

It is a good idea to start organising your collection of negatives at an early stage before boxes, full of unidentified material, lead to confusion. A lot of time and aggravation may be saved if requests for prints from jobs done in the past can be quickly and easily met. After making contact sheets from your developed material, place the negatives in an envelope and store in a filing cabinet or ring folder. The contacts can also be filed in a ring folder. Number and date negatives and contacts and enter the number in a reference book with a brief description of the job and any other details which you might possibly wish to recall at a later stage, such as names, phone numbers and location. Leave space alongside each entry so that in the event that you send out any negative material, you can always make a note where it is in your reference book. When the material is returned this should of course also be recorded. The negatives will be filed successively, whereas the contacts can be filed under subject matter.

Transparency material needs to be severely edited before it is filed and stored. All technically inferior material that is unsharp or incorrectly exposed can be discarded straight away. The final selection can be stored in filing cabinets or ring binders in plastic sheet wallets. If you intend at any time in the future to use a filing cabinet, make sure the wallet is of a type to take the metal bar necessary for storage in a filing cabinet. It is advisable to keep some of the superfluous material that is of an acceptable technical standard, at least for a year or two. I keep this material in the manufacturers' boxes and on occasion, do need to go back to the original material. The deciding factor has to be how much storage space do you have? You just cannot keep everything.

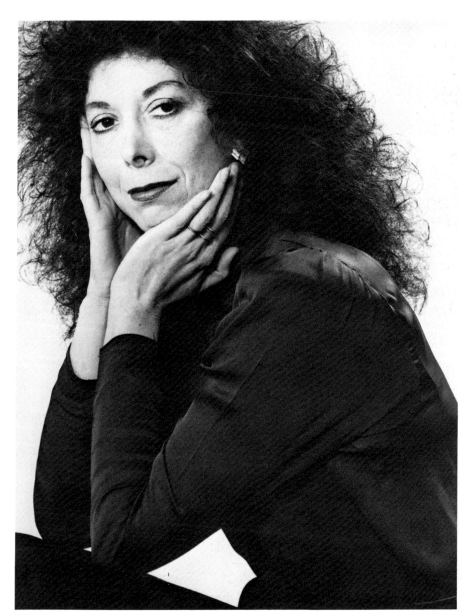

Because I left a fair amount of space around the portrait, I have been able to improve the composition by tilting the image, emphasising the diagonal lines and creating strong shapes along the border of the frame.

Ilford HP4, Mamiya 6 x 7, 180mm, Studio flash

Light from a honeycomb spot directed at the face has eliminated all shadow whilst at the same time giving good modelling to the hands. A second spot on the right highlights the hair and shoulder. The figure is lit by an umbrella flash near the camera position and a fourth light hidden by the sitter illuminates the background.

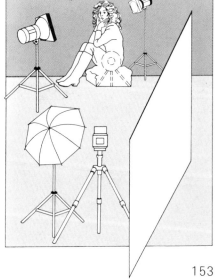

Facing page: **Set of contacts from portrait session.** Two L-shaped cards are excellent for deciding on the crop of the final image.

Almost every print can be improved by printing-in excessively light areas or holding back areas of shadow. In this case I felt that by 'dodging' the lower half of the picture and creating this clean white area, greater emphasis would be placed on the central element of the portrait—the staring eyes.

Kodak Tri-X, Nikon 50mm, 1/125th sec @ f5.6

Recognition and Reward

As time goes by and you become more proficient at portrait photography (and no doubt in other fields as well) so you will start to accumulate a lot of pictures, and eventually you will want your abilities to be recognised. The satisfaction of doing something well enough, for people to be willing to pay you for it, is very great indeed. Not to mention the money which, in a hobby as expensive as photography, will become a necessity if you want to expand your range of equipment. A professional photographer would need to spend at least £1000 per year to maintain and improve his equipment.

The Direct Sale

The easiest and most effortless point of sale will come from word of mouth, through friends. They may have seen your work, or been photographed by you at a time that you were developing your expertise and did not expect payment. When you feel confident enough and satisfied with the results you have been getting, then is the time to let it be known that you are ready to accept commissioned work. Portraits of babies and children are the most likely area where people wish for a better result than the very basic point and shoot, obtained by their own efforts—and are willing to pay for it. If you do get offered these commissions, let it be on your own terms. That is to say, you should be chosen for the type of picture you enjoy taking and do well. Don't try and change your style to supply a type of picture you do not really like and are not good at. When it comes to photographing children and babies, you will be in an area which has plenty of sales potential beyond the original commission.

Take a look at some of the periodicals and magazines that use pictures of babies and children in their editorial pages. The babies tend to be of a rather uniform, posed variety with a very high standard of lighting and colour control. You feel the babies must have gone through an audition for the part (they probably have, since most agencies do also have model babies on their books). With children, a far wider gamut of pictures is acceptable and they frequently encompass the schoolroom, playground or parent-child relationships. Magazines are always on the lookout for different situations, a good variety of expressions and pictures which convey strong emotion. These are all pictures that would also appeal to a fond parent and so the picture you take for the one can also be used for the other.

Picture Copyright

Under the present 1956 Law of Copyright, the commissioner retains the copyright unless otherwise stated. The photographer may retain the negative for sale of prints but publication rights can only be obtained with the consent of the copyright owner. There is pressure to have this law changed so that the photographer always retains copyright of his own work, as is the case in the United States. If the copyright is yours and you sell a picture to a book or magazine, then the price will vary according to the rights you confer. These would normally be for one use in one country. For world wide use you could expect two and a half times the fee. All transparencies and prints should be clearly marked with your name and the internationally recognised © symbol or marked copyright. It is important to get a receipt for all prints and especially for original transparencies. It is not unheard of for originals to be lost, particularly in large organisations. The recognised compensation is £400 per original transparency but unless you have docu-mentation you will have no proof to force the company to pay up.

The Association of Fashion, Advertising and Editorial Photographers (AFAEP), The British Association of Picture Libraries and Agencies (BAPLA), The British Institute of Professional Photographers (BIPP), and the National Union of Journalists (NUJ) have agreed jointly on terms and conditions of sale. These are printed on the back of their standard Delivery Note which can be purchased from the headquarters of any of these organisations (see example). Whenever submitting material, include the Delivery Note which should be signed and returned by the client, thereby acknowledging receipt at the same time as agreeing the terms of sale. In any future dispute over loss or damage, your signed delivery note will be irrefutable evidence of what was agreed. It is worthwhile mentioning that the reproduction fee does not automatically give ownership of print to the buyer. Either charge an additional print fee or make sure the print is returned along with the original transparency material. You will be able to make further sales with this material as long as it does not conflict with the original sale. If these were for first British Rights, you could only effect a further sale after publication.

Model Release

You need the consent of your subject if you wish to submit the photograph for publication. This applies where you have photographed someone in private and for this purpose you need to have them sign a model release form. In return you can either offer a set of prints or possibly a small percentage of the sales. Where you photograph people in public places, you are free to use the picture for editorial purposes but would need their consent if the picture were intended for

...MS AND CONDITIONS OF SUBMISSION AND REPRODUCTION OF PICTURES

...n this Agreement the terms a) **picture** includes a photograph, transparency, neg... montage, drawing, engraving, or any other item which may be offered for the ... **reproduction** includes any form of publication or copying of the whole or par... printing, photography, slide projection (whether or not to an audience) xero... illustration, layout or presentation, electronic or mechanical reproduction on th... **Return** is the date by which pictures must be returned as specified on th... material, if no date is specified, date for return shall be four weeks fro...

No variation of terms of conditions set out herein shall be effective un...

2. Pictures are supplied on loan and no property or copyright in any ... submission or on the Supplier's grant of reproduction rights in an...

3. A non refundable **service fee** to cover administrative costs a... each submission and resubmission of pictures whether or n... pay for courier, express or any other special **delivery** arra...

4. The Supplier's delivery note will list all the pictures del... been received in good condition unless within five wo... of any discrepancy or damage.

5. The Client is asked to return every picture by its ... necessary insurance and protection must be gi... delivery note listing and totalling the return o... by the client in case of loss.

6. Unless otherwise agreed each picture ma... the Client shall be liable to pay a **holdi**... Payment of the holding fee does not ...

7. a) Risk in and responsibility for ... returned to the supplier in the co... of any known loss or misuse of ... party. If a picture is not return...

8. b) The Client shall be lia... especially for original trans... compensation shall be £4... loss suffered by the sup... rights in any picture. ... damages.

c) A picture su... with the compen...

9. Any picture re... replacement ...

10. Reproduc... the Sup... text (i... to us... spe...

11. ...

Delivery Note

FROM:

TO:

ORDERED BY:

1.
2.
3.
4.
5.
6.
7.
8.
9.
10.
11.
12.

DELIVERY NOTE NO.

DATE

DATE FOR RETURN

SENT BY: MESSENGER ☐ REGISTERED POST ☐
RECORDED DELIVERY ☐

SUBJECT:

FOR:

DESPATCHED BY:

13.
14.
15.
16.
17.
18.
19.
20.
21.
22.
23.
24.

TOTAL NUMBER OF TRANSPARENCIES

TOTAL NUMBER OF PRINTS

PLEASE KEEP ON FILE
These pictures have been sent on loan. Discrepancies should be advised immediately. Pictures should be returned or reproduction rights ordered by the Date for Return to avoid holding fees (see clause 8). Please get in touch with us if you desire an extension of the Date for Return.

Please sign and return carbon to acknowledge safe receipt.

Signature ... Date

PLEASE READ TERMS AND CONDITIONS OVERLEAF. If these are not acceptable then the goods must be returned immediately. Signature of acceptance is the basis of a binding contract.

promotion or advertising. If however, people felt they had been maligned, as for instance using a picture of a normal child to illustrate an article on retarded children, you could find yourself faced with a law suit.

The Picture Agency

If you intended to make photography your profession, one of the first steps would be to put together a portfolio of your work. You would then phone or write to a variety of magazines and periodicals which have an affinity with the sort of work you are doing. Wherever possible, you would try to arrange a personal meeting with the Picture Editor, to introduce yourself and show your portfolio, with a view to making a sale or obtaining an assignment. This does imply a full time commitment. For the keen amateur with a good body of work to show, the ideal sales outlet would be the picture agency or picture library. BAPLA has over 125 members with the great bulk of them situated in or around London. They have a Directory of members but many of the larger agencies may be located through the yellow pages. Those hundreds of transparencies that now fill inumerable drawers or filing cabinets could be out there working for you.

Making a Submission

The first obstacle to be overcome is to choose the picture library or agency that is the most likely to handle the sort of work that you do. Write off to BAPLA head office for a copy of their directory in which all members are listed with a short description of their strengths and any specialisation they may wish to be known for. Some agencies deal with black and white prints but the majority now concentrate on colour work. The larger agencies will have on their files hundreds of thousands and in some cases millions of transparencies. They are not interested in the photographer who has only a small selection of transparencies to offer. You need to have at lease three hundred pictures for your initial submission and those three hundred should be what is left after you have made your own critical selection.

Having made a good selection of your best work, you are now ready to approach those agencies or libraries which you have chosen from the BAPLA directory. The sort of letter that says 'I am a photographer—what pictures do you need?' (and there have been examples) won't get you any further than the nearest waste paper basket. The agency want to know, clearly and concisely, some very basic information. State how many years you have been taking pictures, how well travelled you are, what format you work in, whether you have black and white material as well as colour and also whether the colour is negative film or reversal. Give a brief description of the work you intend to submit as well as the names of any well known people included. Finish by requesting an appointment to show your work (in person if possible) and why not enclose a self addressed stamped envelope? It is only being polite and creates a good impression with the people with whom you hope, in the future, to be doing business. Agencies take 50% of the fee, which probably sounds extortionate. A good agency will always get the best possible price. You are just as well off with 50% of £100 as with 100% of £50.

Once your work has been accepted, don't expect instant results. It would be quite normal to wait 9 months before the first cheque comes in. After acceptance, your photographs need to be edited, numbered, cross referenced and categorised before they are put in the files and become available for picture researchers. The researchers (who are employed by all major publishing houses) are selecting well in advance of publication and the photograph cannot be priced until the agency knows exactly how it is to be used. Once that decision has been made, it can still take anything up to three months before the agency is paid, and as they usually pay their photographers every quarter, nine months is easily accounted for. You should reckon to leave your material for at least four years and make sure it is exclusive to the agency. You will do yourself no good at all if it is discovered that you have left a copy transparency with another agency.

When you do finally make a sale, more likely than not, it will be to some obscure publication that you have never heard of, possibly a foreign one. All the larger agencies are represented abroad and it is then that you realise the true worth of the agency in finding a market for your picture that, on your own, would be quite impossible.

Facing page: **Delivery note as agreed between AFAEP, BAPLA, BIPP and the NUJ, 1984.**

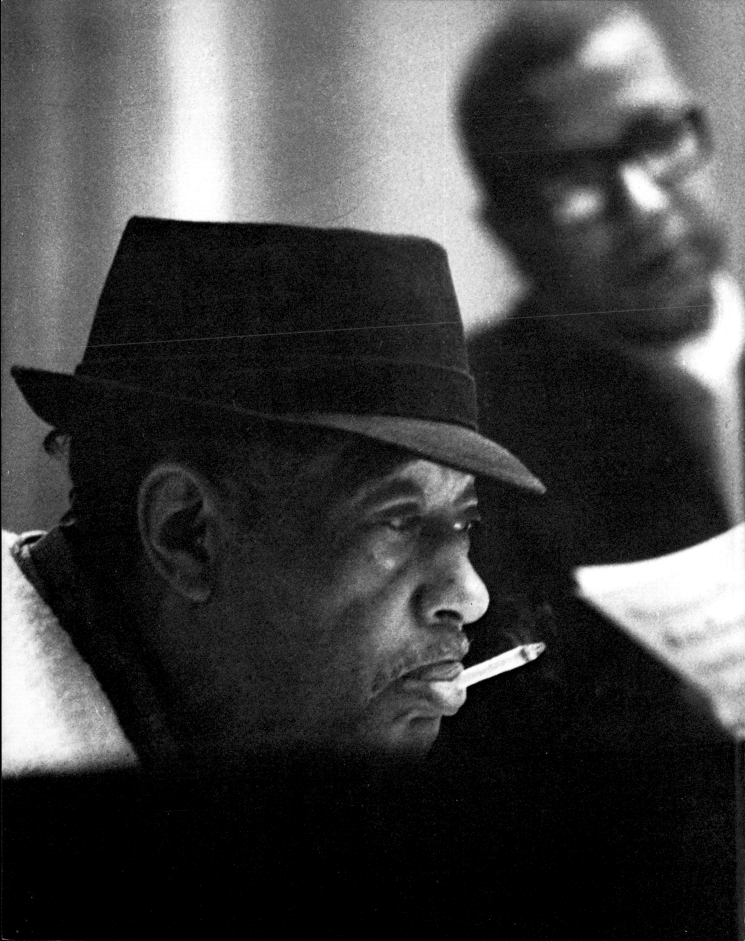

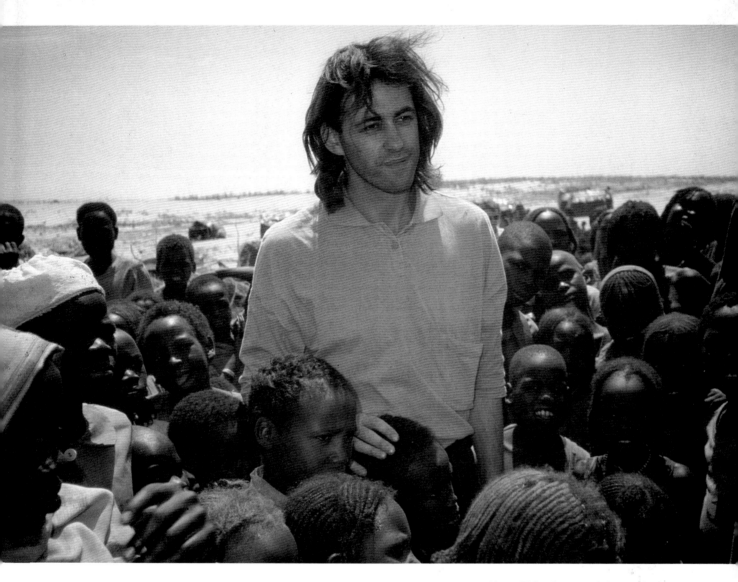

Above: **This photograph has sold to countless magazines throughout the world. I accompanied Bob Geldof on his tour of the Sahel states of Africa but even so, he was very sensitive about being photographed amongst the distressed and starving people we visited. I had to show that I would not photograph him in a way that he disliked, in order to gain his co-operation.**

The sun was almost perpendicular in the sky at the time I came to take this picture—not the sort of lighting one would choose. Fill-in flash was the only way of overcoming the harsh shadows.

Kodachrome 64, Nikon 35mm, 1/125th sec @ f8, Fill-in flash

Facing page: **Unlike a lot of products, a photograph may become more valuable with age. If you do get an opportunity to photograph some well known person, the chances of making a sale may be as good or even better in the future; as with this portrait of Duke Ellington, taken when he came to London in the early 60s.**

If I have the opportunity I like to spend one or two hours over a portrait, especially if it is taken in the person's own setting. With the famous you may not get much more than that in minutes, as on the occasion I photographed Sean Connery. He is someone so at ease with the camera and so devoid of subterfuge that, in spite of a session which lasted no more than ten minutes, I felt quite confident of the results.

Kodak Tri-X, Nikon 50mm, 1/60th sec @ f4